The Urban Sketcher

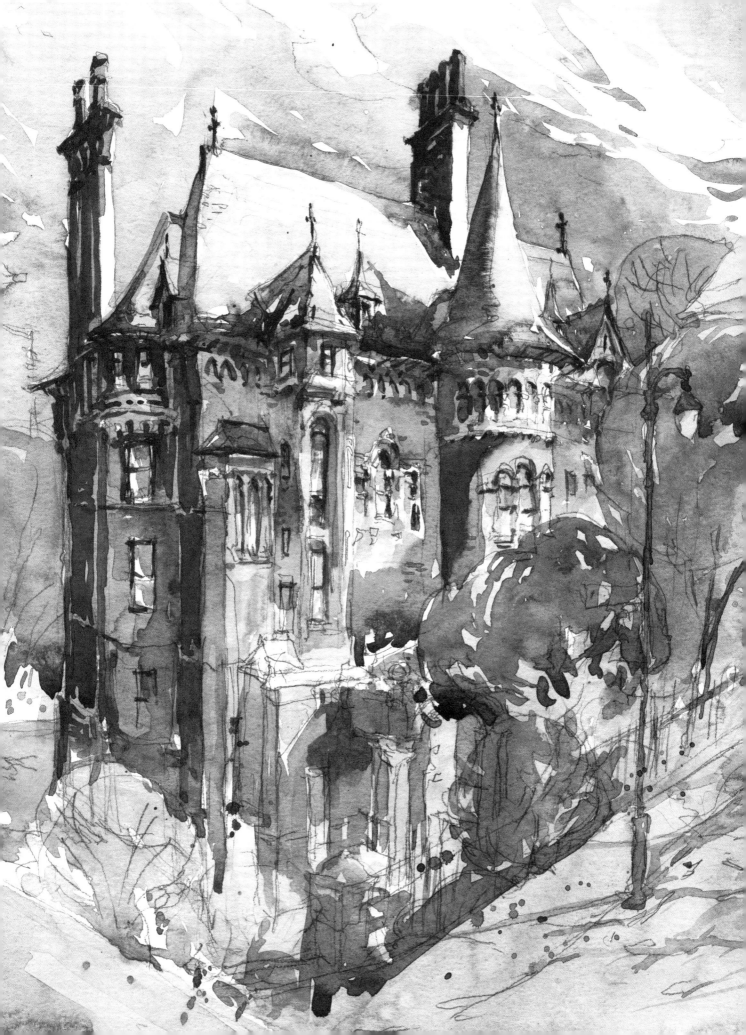

The Urban Sketcher

TECHNIQUES FOR SEEING AND DRAWING ON LOCATION

by Marc Taro Holmes

Meredith House, Montreal
Pen, ink and watercolor on 140-lb.
cold-pressed watercolor paper,
16" × 20" (41cm × 51cm)

NORTH LIGHT BOOKS
CINCINNATI, OHIO
artistsnetwork.com

Chapter 1

Graphite: Draw Everything You See 12

Chapter 2

Pen & Ink: Expressive Lines, Powerful Contrast 38

Chapter 3

Watercolor: Bring Sketches to Life with Color 90

What You Need

Graphite
0.7mm mechanical pencils
kneaded eraser
sketchbook

Pen & Ink
ballpoint pens
brush pens
fountain pens & dipping nibs
ink and water bottles
smooth surface drawing paper

Watercolor
artist quality pan watercolor paints
natural & synthetic brushes ranging from nos. 0 to 20
textured watercolor paper

Santa Domingo, Columbus
Pen, ink and watercolor on 140-lb. cold-pressed watercolor paper, 11" × 15" (28cm × 38cm)

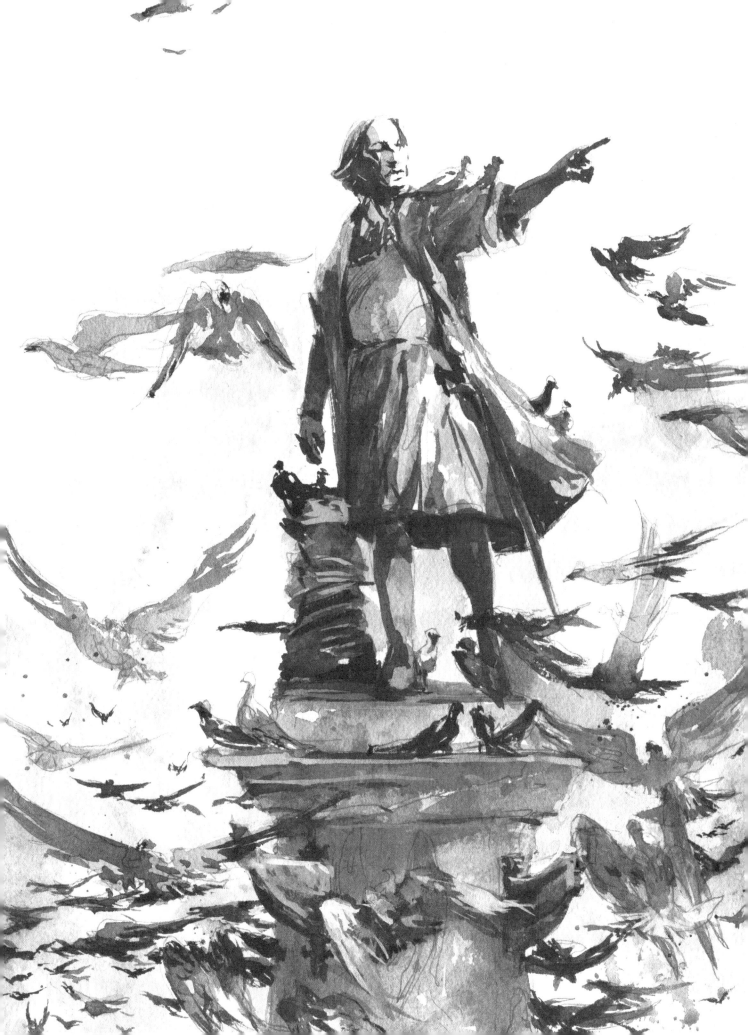

Introduction: How to Use This Book

This book contains a self-directed urban sketching workshop that will take you step-by-step from sketching simple objects to reporting from the streets and alleys of foreign cities. Each step, each lesson, each exercise builds on the one before. Everything you practice will make the next step easier.

We'll start with basic pencil drawing, then progress through pen and ink, and finally, touch on painting in watercolor. We'll practice first with isolated objects, then move on to street scenes. Before you know it, you'll be drawing architecture in the city, and eventually, people and events as they happen in real time.

The leaning process laid out in this book represents years of my own experimentation, distilled to the very essence of sketching. Artistic skills, like any rewarding activity, take time and practice to develop. It's much like lifting weights or training for a marathon. You might not notice a change one day to the next; only after weeks or months can you look back and see your progress. The important thing is to enjoy the process.

It's okay to take your time with these projects. If you find yourself becoming frustrated, just go a little slower. You can also repeat the same projects more than once with different subjects. Each time you try it, you'll improve your skills and learn a bit more.

If you work through the exercises and step-by-step demonstrations in order, using places and things found in your daily life, you'll gradually be introduced to all the essential skills of urban sketching. What's even better is that you'll be out in the world sketching from the very first day. You'll experience your city in a new light, you'll get better drawings by working first hand, and you'll bring back stories to go with them.

Montreal's Place d'Armes
Pen & ink on Strathmore Series 300 Bristol,
14" × 17" (36cm × 43cm)

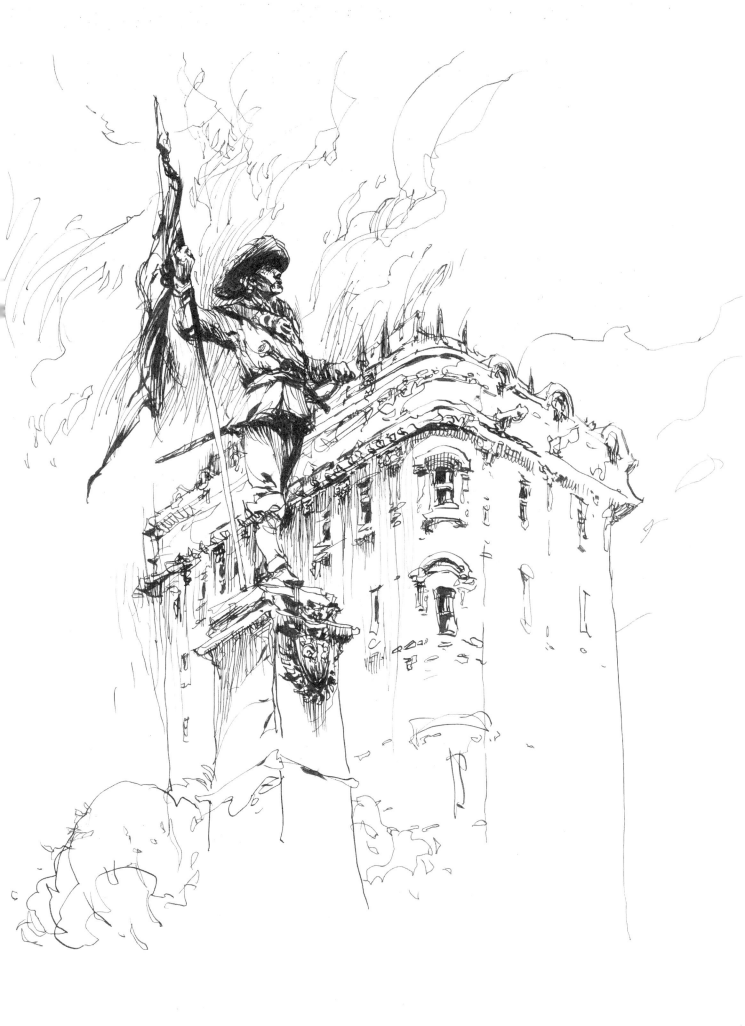

What Is Urban Sketching?

People have been sketching life in the streets since before streets existed. We have artwork recording daily events as far back as prehistoric caves. Drawing our life stories seems to be a universal part of human nature. But, when I talk about urban sketching today, I have a particular thing in mind.

While any sketching in any city might be called urban, today the term *urban sketching* (often shortened to USk), refers to an international artistic movement that was launched in 2007 by artist and journalist Gabriel Campanario.

Initially based in the popular photo-sharing service flickr.com, later expanding to blogs and social networks, the USk movement quickly spread around the world. At the time of writing there are over 60 regional chapters representing most major cities, with more forming every day. There are free sketching outings, organized weekend workshops, and an annual international symposium that brings hundreds of sketchers to a carefully selected host city.

Just search online for your town and "urban sketchers" and you stand a good chance of finding someone working in your region. Or, if you live in an out-of-the-way area, you can join in just by following our social media. People are posting sketches from every corner of the world, covering every possible subject.

The core of this internet-enabled sketching phenomena is the website, UrbanSketchers.org. This is a collaborative online journal that currently features one hundred hand-picked artist-correspondents. Artists involved are chosen for their passion for sketching, willingness to freely share their work, and to represent the

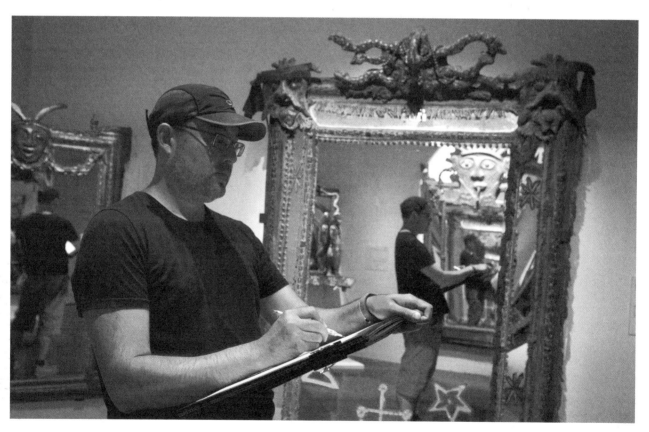

Museum Sketching
Try starting at the museum. They have interesting subjects, professionally displayed. Here I'm traveling light, using three drawing boards with paper taped to both sides, a pencil and a kneaded eraser. Museums usually encourage drawing, but generally, no liquid ink or paint is allowed. (I stand to sketch, so I can promptly move out of other patrons' view.)

widest array of cities around the world. That's the best place to start learning more about us. There's an archive of thousands of drawings for you to explore.

We are best known for one core principle: We draw on location, wherever we live and travel, and we share our sketches and stories freely on the web. For many of our passionate sketchers, it's a way of living life to the fullest, experiencing it as only an artist can.

There is a kind of collective agreement that to be a true urban sketcher you must draw from life, entirely on location. To tell a story in the moment, recording your own unique artistic impression. This is, of course, a strictly self-imposed challenge. Sure, you can go home to a comfortable studio and make wonderful works of art. But if you commit yourself to drawing on the spot, to getting it all done in one session as events are unfolding around you, you can achieve a freshness, a direct impression that can't be matched in a more relaxed drawing situation.

To me, this is the main attraction. Urban sketching gets you out in the world looking for things worth drawing. It puts you into a mindset where daily life is part of a larger artistic adventure. You begin to see things around you in a different way. You're not simply moving around your city from work to shopping to whatever. There is no driving on autopilot. You're always on the lookout for drawing opportunities.

Be it scenic views, places where people gather, or events that call out to be sketched and shared, I'm always thinking—what goes on in that place? Could I get into this building and sketch? What's down that alley? What events are happening this weekend? The city becomes your studio. The subjects are out there waiting for you.

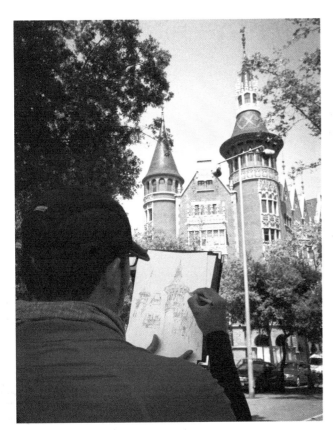

Casa de les Punxes, Barcelona
Sometimes it's best not to try for the whole thing. Instead focus on the most unique elements, like this building's towers.

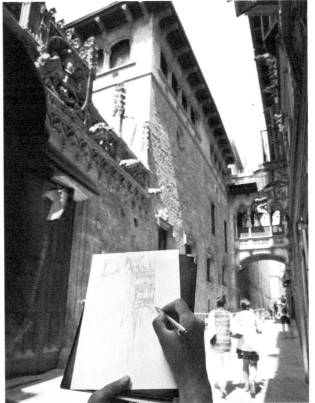

In the Gothic Quarter, Barcelona
In crowded areas like this, work fast in pencil, just sketching the main structure. Save the shadows for later.

Get Started As a Daily Sketcher

Just to show you how easy this is, here is how you can get started—without any drawing instruction at all.

Part of the reason sketching is such a rewarding art form for so many people is its natural speed and simplicity. You don't need a lot of equipment and it doesn't take a great deal of time—just a few minutes each day.

(Actually I'm trying to trick you, because once you've broken that natural resistance and begun drawing, it's easy to get lost in your book and end up sketching for ten or twenty minutes.) No matter how busy you are, though, this is an easy way to make art a part of your life.

Take Your Supplies Everywhere
For an entire month, don't leave the house without taking along some simple drawing supplies. Commit to having drawing supplies with you every hour of every day. Just the basics—don't bog yourself down with so much stuff that you'll start to find the slightest excuse to leave things at home. A tiny 3" × 5" (8cm × 13cm) pocket sketchbook, a pencil and eraser, or maybe a couple pens are all you need.

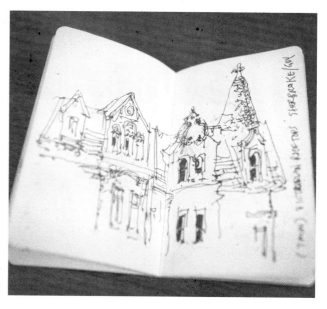

Draw Constantly
Start and keep the habit of drawing every time you feel the inclination. Draw in every stolen moment, using all of life's little delays as bonus time. This is the best and easiest thing you can do to succeed as an urban sketcher.

Whenever you're waiting for something—the bus, friends you're supposed to meet, whatever it is—just pull out your sketchbook and do a tiny drawing of what's closest to you. Don't think about where you have to be, or anything else. Just give yourself five minutes to pull out your book and do a quick sketch.

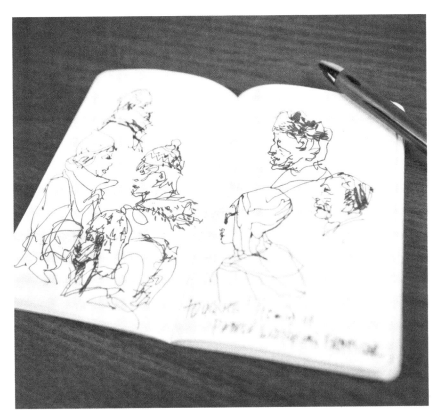

Go Easy on Yourself

This is the most important thing. Don't judge your sketches in any way. Every sketch is a good sketch. Just keep doing them. You don't even have to show anyone. Judge your progress only by how many pages you fill. The result doesn't matter—only the act of drawing—the fact you put pen to paper and made a mark that day.

If you can turn off your internal critic and judge yourself only by quantity, you will have discovered the true path to mastery. You'll see your sketchbook filling up very quickly. That's always a nice reward. In time you'll feel the drawing comes easier. You'll feel your artist eye seeing everything. You will start to spot drawing subjects in your neighborhood, your local shops, even your own home—subjects you never noticed before.

Find Subjects All Around You

Indulge yourself by sketching anything that catches your fancy. If you're a commuter, take out your sketchbook instead of your phone. If you work in an office, you can probably steal a few minutes to look out of a window and do a quick sketch. If you're a smoker, well then, you have plenty of opportunity. If you watch TV or play video games, hit pause and sketch what you see on the screen.

Fill A Sketchbook in a Month

If you can keep this state of mind of recording everything, treating it like a kind of diary, you can finish a small sketchbook in a month. After you fill your first book, congratulate yourself. Then immediately start another.

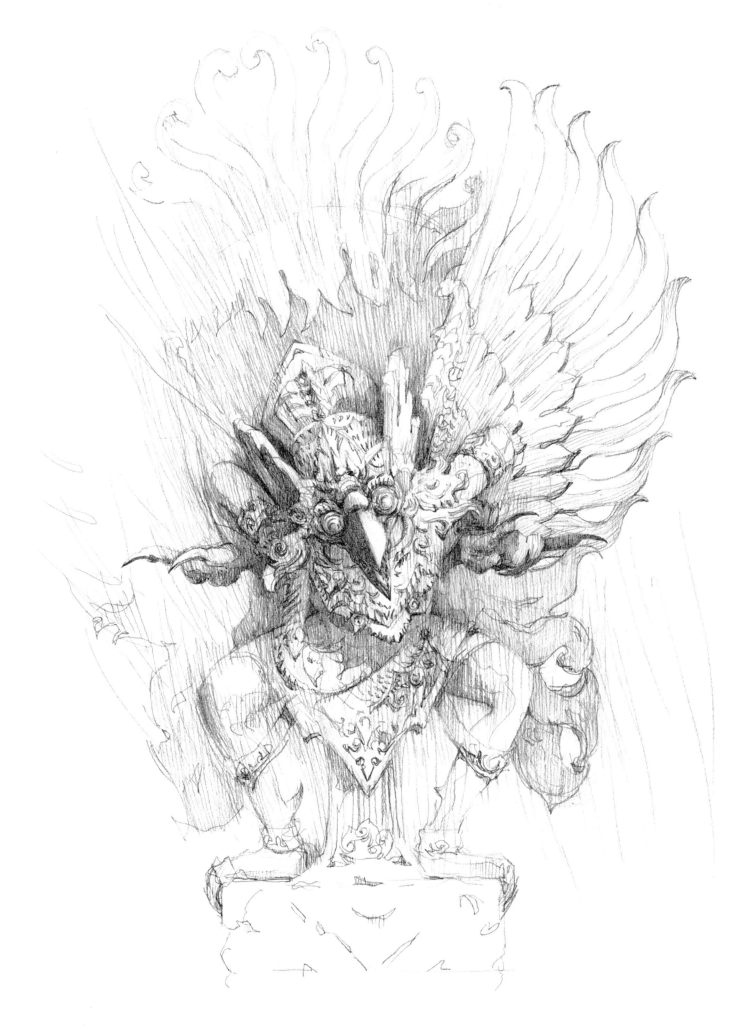

Graphite: Draw Everything You See

. .

The humble pencil is really a hero in disguise. It's portable and erasable, as well as being capable of both fine linear draftsmanship and broad areas of tone. Even strong darks can be created with a pencil, if you're patient enough to work over an area a few times.

Challenge yourself to go out and sketch with only a pencil, leaving all your other gear at home. (Yes, without the color we all love, just for now.) It might seem limiting at first, but really, the entire spectrum of art is included in that slender stick of graphite.

In this chapter, you'll use the pencil to teach yourself the foundation techniques of drawing from observation. If you stay away from color in the beginning, you'll benefit from learning design principles in black and white. You'll see there is plenty to be learned about line work, light and shadow before we add in the complexity of color.

Key Concepts In This Chapter

- Drawing From the Outside In: Describe any object quickly and accurately. Learn to establish a correct silhouette with sight measuring before investing time on interior details.

- Shadow Shapes: Make things look realistic by creating the illusion of depth.

- Composition & The Gradient of Interest: Design pages to tell stories and lead the viewer's eye wherever you want it to go.

Graphite Tools

It doesn't take much gear to get started in urban sketching. Often you'll find you do your best work with just the most basic tools and materials.

- **Mechanical pencils** come in varying degrees of lead thickness. I prefer 0.7mm lead because the line is bolder and it doesn't break as often as the conventional 0.5mm. Personally, I don't enjoy wooden pencils because you have to constantly sharpen them and deal with the dust and wood flakes.

- **Kneaded erasers** leave no eraser crumbs. They can be sculpted, or kneaded, to erase small areas and can be blotted to lift tone.

- **Sketchbooks** are available in a wide variety of shapes and sizes and range from inexpensive to pricey. The most popular choice still seems to be the classic Moleskine sketchbook. Recently I've started using the Stillman & Birn Alpha Series. Hand Book artist journals also come highly recommended by several artists I know. The most important qualities in a sketchbook are a sturdy binding that will withstand being carried around every day and good paper that can take any media and can be trimmed out and framed.

Coated Stock for Pencil Drawing
I look for sketchbooks with clay coated paper such as this Moleskine. Sometimes I use cut sheets of 100-lb. (210gsm) plate finish Bristol. Avoid rougher paper textures as they make for blurry drawings. You want it smooth for sharp detail and subtle tones, especially when drawing small in a pocket-sized sketchbook.

Drawing From the Outside In

Urban sketching is about observing the world, witnessing and recording. Thus, we want to be able to draw reasonably accurately. That does not mean photographically real—that kind of drawing is for studio artists who want to spend a great deal of time on a drawing. As urban sketchers, we want to simply sketch in a descriptive way to show people our stories. We want them to not only see what we've seen, but also to feel what it was like to be there.

To that end, we must be able to draw anything we might encounter. We can't be good at faces but not at architecture, or avoid cars because the shapes are complex. We need an all-around comfort with drawing, where any subject is equally achievable.

Drawing from the outside in is a principle I've adopted in approaching all my sketches. The idea is to work larger-to-smaller, establishing the big shapes before investing time on the details. It's a very fast way to sketch. A lot of problems with these outside shapes can be solved by doing corrections when things are still simple outlines.

Try to spot any errors in proportion in the first few minutes of a sketch. There's nothing more frustrating than drawing in a lot of interesting details, only to realize you've drawn an important element out of scale. Or that you haven't judged the height right, and you're about to go off the edge of the page. That has happened to me many times, but there are two simple techniques I call "sight measuring" and "angle checking" that can help you spot these issues early on. They are a simplified version of what is taught in fine-art ateliers as *sight-size drawing*.

Sight size, when done in the traditional manner, is a technique for the perfectionist. The artist must stand at a set distance from the subject and draw the subject to the scale it appears from that distance—the exact size that is in sight. The drawing is positioned vertically on an easel, directly parallel to the model. Precise measurements (using calipers and plumb lines) can be accurately checked between the drawing and the subject. It gives you a perfect drawing, but it it's only for the most patient and determined of artists.

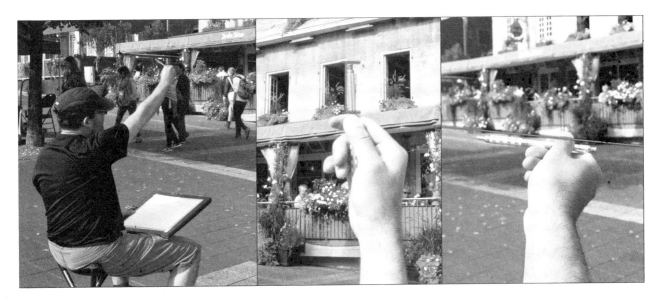

Sight Measuring and Angle Checking

You are probably familiar with the image of the artist with his arm extended, holding a brush upright, thumb up like a hitchhiker. This is not just a funny stereotype of an artist—it's a real measuring technique. In this shot I am checking things like the angle of the sloped street, and the height of the windows.

Sight Measuring & Angle Checking

This sake set is a great introductory subject for sketching from the outside in. Get the outside silhouette shape first, spot check your accuracy, and then proceed to subdivide into smaller and smaller details until the whole thing is drawn.

My feeling is, you should do whatever measuring you need to do so that you are satisfied with your drawing. You decide how accurate you want it to be. I enjoy it when everyone can easily recognize my subjects, but I don't want to be doing so much measuring that the drawing feels mechanical. Accuracy is a skill that should allow you to do more challenging things, not slow you down.

Materials

sketchbook

0.7mm mechanical pencil

kneaded eraser

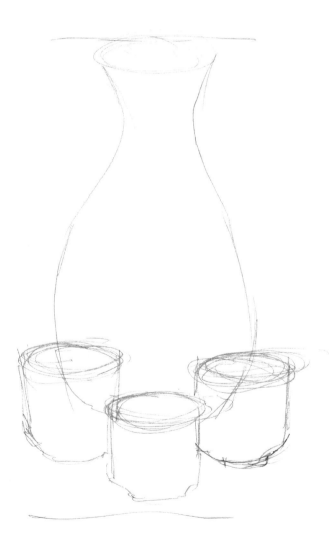

1 Decide roughly how large you want the sketch on the page. Mark a small dash at the top and the bottom of your subject and lightly sketch a scribble of the outside shape. Don't add internal detail, just focus on the silhouette, as if it was cut out of a piece of paper. This simple outline sketch is all you need to do to ensure accumulating proportional errors don't expand off the edge of the page. You have a "box" to work within. All future details will fit inside this box.

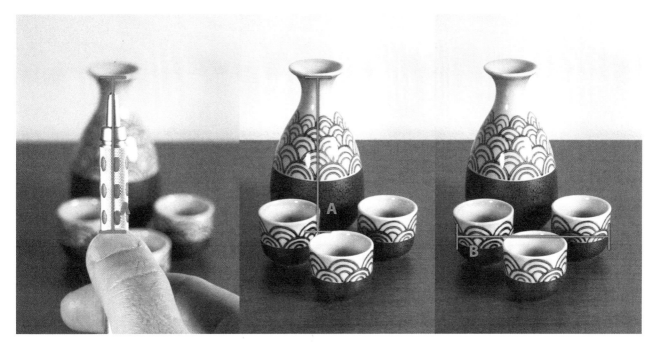

2 As you look at the subject, extend your arm straight (elbow locked), and line up the tip of your pencil with the top of the subject. Slide your thumb down until it's lined up with the base. That position you've marked on your brush or pencil—that is a unit measure you can use to check against other objects. (Line A). Keep your thumb in position on the pencil to preserve the measurement you have marked. Keep your elbow locked to maintain the same distance from the subject. Don't move your feet either. If you step back, the scale of everything will change. Look for something you can compare your measurement against.

It so happens that the height of the jar is equal to the width across the three cups. (Line A = Line B). This gives us something we can check in our drawing. There won't always be a perfect match. Sometimes you'll have to estimate.

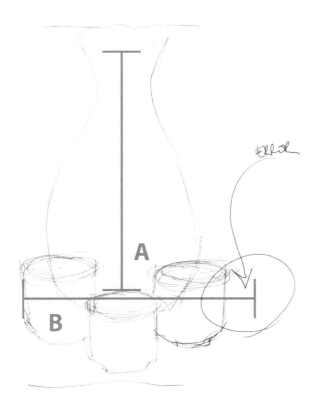

ERROR

3 Now compare the height and width of the sketch—oops! The drawing is not correct. See how we have caught that error with this simple measuring trick? This is a pretty small error, which can be fixed by refining the sketch. Make the fix to the silhouette so that the jar height (A) matches the cup width (B).

Sketch in the dividing line between the dark ceramic base and the upper patterned area. This is what is meant by working larger-to-smaller. Once you have the outside shape, what is the next biggest thing you can draw? The waist of the bottle is the next-largest shape, dividing the jar in half.

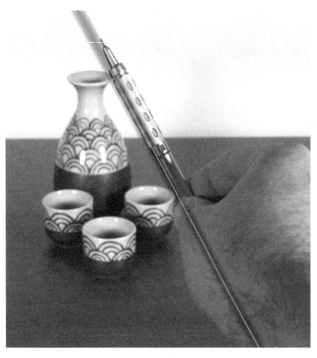

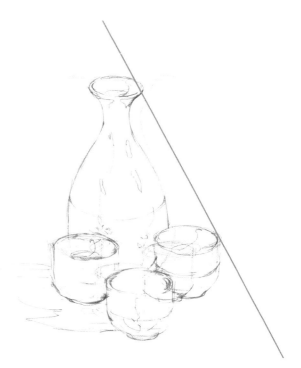

4 The next kind of measurement is what I call an angle check. It's is ideal for finding roof lines, or checking perspective on narrowing city streets. Measure the slope between two points. Place the base of the pencil on the first point, (the edge of the cup) holding the pencil vertically, then rotate the tip until it lines up with your second point (the lip of the jar). Now lock your wrist. Don't move the angle of the pencil. Simply place it over your drawing and see how well the angle lines up with what you've drawn. It's looking reasonably close after widening those cups.

5 The blue lines are the original scribble. See how far out it was at first? Now that you've confirmed the silhouette, you can kick back and have fun. By starting outside-in, you can see for certain that you have a shape you like before you get into those details. Freely scribble in the pattern. Don't stiffen up while doing it. You wouldn't feel as free if you weren't sure about the underlying structure, and it wouldn't turn out as loose and sketchy as you want. Oddly, it's the measuring that allows the sketch to look spontaneous. Many artists use the saying, "Loose is how a drawing looks, not how it's made."

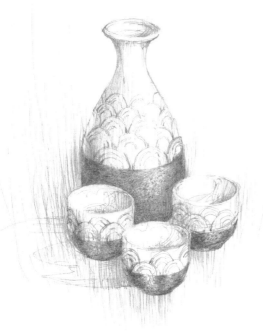

The Finished Drawing
While the drawing isn't perfect, it is fairly faithful to reality because the subject was a relatively easy one. As we move on through the book you'll see I only use as much precision as I need to get the sketch on paper. Those measurements only took seconds to do. In no way should it be hard labor.

Use Simple Measurements to Break Down Complex Shapes

Let's go through this one more time with a more challenging example—this Garuda figure. It's a very complicated subject, so don't hold yourself to too high a standard of accuracy at this point, or you'll make yourself frustrated. It doesn't matter if you get every feather in place, or if all the chips and swirls of the relief carvings are perfect. You just want to get the feeling of this fantastic creature into your sketch.

The trick is finding what simple measurements can be used to break down this complex shape. Don't confuse yourself with a lot of geometry homework—just find a few hints as to the height and width.

Materials

sketchbook

0.7mm mechanical pencil

kneaded eraser

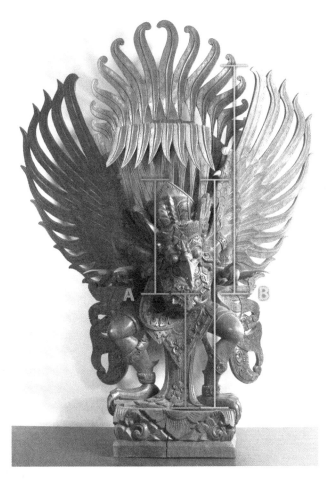
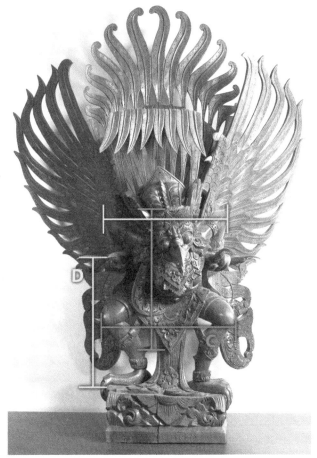

1 Break down the shapes with measurements. The head, (from beak to crown), and the legs (from feet to beak) are actually the same height. (Line A). This means the very tip of the beak is close to the center of the figure. Also, the whole height of the figure matches the height of the wing. (Line B). You can also see that the width of the knees (Line C) can be checked against the torso from the tip of the kilt to the center of the forehead. The width of the elbows can be compared to the height from fingernails to the ground under the feet. This gives you a pretty good box to work inside.

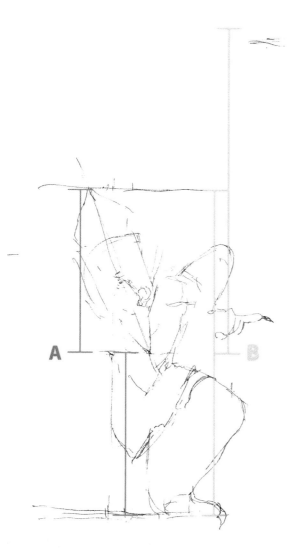

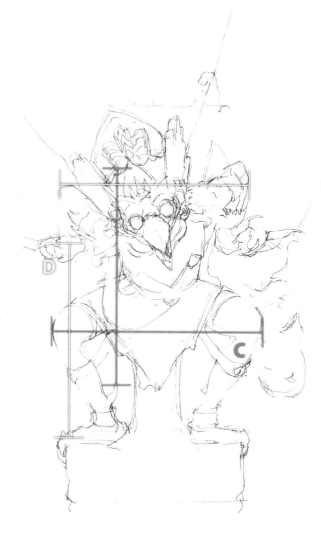

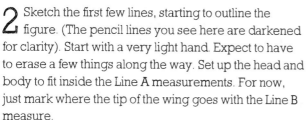

2 Sketch the first few lines, starting to outline the figure. (The pencil lines you see here are darkened for clarity). Start with a very light hand. Expect to have to erase a few things along the way. Set up the head and body to fit inside the Line A measurements. For now, just mark where the tip of the wing goes with the Line B measure.

3 Move onto the left side to complete the silhouette. Do some angle checks to test the slope of the limbs and the find the points of elbows and knees. Fill in the shape of the crown and sketch the basic shape of the wing. Don't try drawing the individual feathers just yet. At this point you're starting to have a silhouette, and should even be feeling confident with the sketch. Put a few details on the head and crown, just to see how it might look as it comes together. (Even though, really, you should wait on that.)

Measurements at C and D are pretty close, so we're on track—the figure fits inside the box. Take a moment to fix any minor errors before they become bigger problems. (The biggest "mistake" in this case is that I've unconsciously exaggerated the tilt of the head. But I decide I don't actually mind. It's not correct, but it adds some emotion, some life to the pose.)

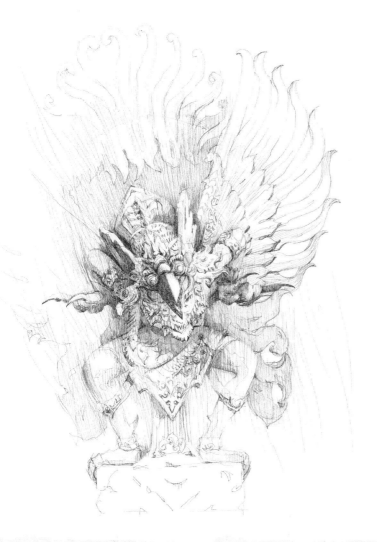

4 From here on out it's party time. The measuring took a few minutes to sort out, but it was worth it, because now you can just draw!

Point-of-View Check

Here is a nice way to determine if you're "done." This is a trick I was shown by Belgian urban sketcher Gérard Michel.

Face the subject and hold your drawing directly in front of your face, superimposed over the subject. Raise and lower the page in and out of your view a few times, up/down, drawing/reality. Keep rapidly flipping back and forth a few times, and an optical effect will occur. You can achieve an after-image animation effect, where you can see your drawing superimposed on life. You'll be able to see how well the drawing lines up. You might have to shift your position back or forward to get this effect to work. Adjust until the sketch is at sight-size with the subject, (the same height on the page as it is in reality). If you do this a few times during a sketch, you can spot some course corrections you might want to make.

Just keep in mind, it doesn't have to be perfect. Sometimes I do the fixes, sometimes I say, "That's okay, I like what I got." In the case of this complicated carving, I'm happy with the likeness. Either way, this trick gives you immediate feedback about what you have on the page.

Exercise 1

Still Life Cafe Sketching

For your first urban-sketching outing, head somewhere you can work in comfort, with nobody rushing you. It should be a place where you can work indoors at a table. Your local coffeehouse would be a fine location. Or, if it's in your budget, a nice restaurant where you might spend an evening. The idea is to insert a sketching project into something you would do anyway. Chances are, you're going to go out for dinner at some point. Why not bring your sketchbook along?

Sketch the commonplace still life objects you find—glasses and tableware, perhaps your meal itself. These should be good drawing subjects for the beginner, and at the same time they tell a story of your night out. Use these studies as a chance to practice sight measuring. Check the height and width of objects. See if you can confirm the measurements on your drawing.

If you can get even one sketchbook spread done it's a start, but you could probably get at three done over the course of a night out.

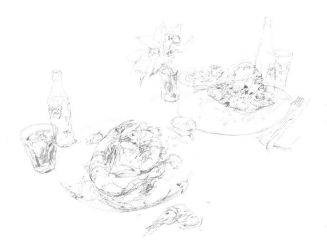

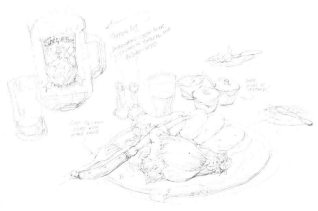

Cafe Sketch

The café sketch is a classic urban-sketching subject. You could dedicate a whole sketchbook to this (and many of us do!). It's your own illustrated guide to the best hangouts in town. This also is an excellent activity for a sketcher group.

Where to Sketch

You could do this anywhere, but it's more adventurous to try something new. Is there an ethnic restaurant you've never tried? Korean food is good for sketching—they go all out on small plates of pickles and spicy bits. Tapas or sushi are also good food subjects. Moroccan or Indian restaurants can have interesting table settings you don't usually find in other places.

Maybe go for dinner and order a fancy desert, but ask for it served with the meal. Then sketch dessert as you eat your dinner. This way your food doesn't get cold. If you're willing to be extravagant, order for an invisible person, and sketch their extra meal while you eat yours. You get a sketch, and some take out!

Visit artistsnetwork.com/theurbansketcher to access bonus lessons.

Exercise 2

Sketchbook Treasure Hunt

You're off ... in search of unique objects! Head out for a few hours and see if you can fill at least three sketchbook spreads with things you have never drawn before. As you encounter objects with more complexity than the previous café sketches, just stick to the strategy of drawing from the outside in and sight measuring to check your silhouettes before adding detail.

You don't need to make a special trip. You can do this as part of any shopping. There are plenty of subjects at the hardware store. Grocery shopping will work too. If you're not really into shopping, that's okay. Look for objects you can isolate from the confusion of the world around them, like certain parts of building—rooftop domes, bell towers or decorative balconies might be sketched as vignettes (drawn on their own with the background left unfinished).

Try to put yourself under a little more pressure, sketching more complicated things, and try for unique objects every time. If you never draw the same thing twice, you'll be learning something every time.

What to Sketch

It doesn't really matter what you draw, as long as it is unique and interesting to you. Look for specialty shops with their own theme. Perhaps you know a place that sells musical instruments, maybe a great toy store, or an Asian import shop filled with knickknacks. Maybe your town has a swap meet or flea market. Or, it might be more your style to head to a high-end mall. These locations should give you plenty of sketching opportunity and some vicarious entertainment at the same time.

Shadow Shapes: The Illusion of Depth

Now that you've had some practice drawing things in line, let's focus on creating the illusion of three dimensionality with what I will call *shadow shapes*.

Human vision involves the brain interpreting patterns of light—how it reflects off an object's lit sides, or when it is blocked by the bulk of an object. If we see shadow on the opposing side, we know instinctively that an object is solid.

The brain interprets drawings in the same way as it sees the physical world. It doesn't matter if we've invented those shadow patterns on paper. The viewer's brain thinks they are real.

In the real world, tonal values are subtle and may be disorganized. Reflection of bounced light, or stray shadows from other objects can form complex patterns which make what we are seeing unclear. Beginning artists often over emphasize these complexities, adding too much texture in the shadows, or overstate subtle shading in the light, making an image look dirty.

For a sketcher, who seeks to make an instant impression, the most important thing is to simplify, to see an ideal, "clean" version of reality. You can learn to see shadow shapes as a graphic design that can be isolated and drawn descriptively. Properly done, it will make an object look solid.

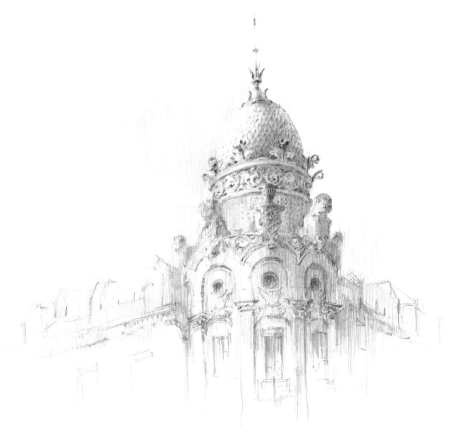

Shadow Shapes

This sketch has many examples of descriptive shadow shapes. The soft gradients on the dome and on the curved corner of the building below tell us these are rounded surfaces. Care was taken to make a smooth gradient so it looks gradually curved, yet still preserves the reflected highlight. The cast shadows on top of the dome tell us that it's made of tiles. All those little edges make a distinctive surface texture. More of these dark shapes in the band below create the impression of carved ivy patterns. Small ledges cast shadows inside the stone arches, in windows, between bricks and under roman capitals.

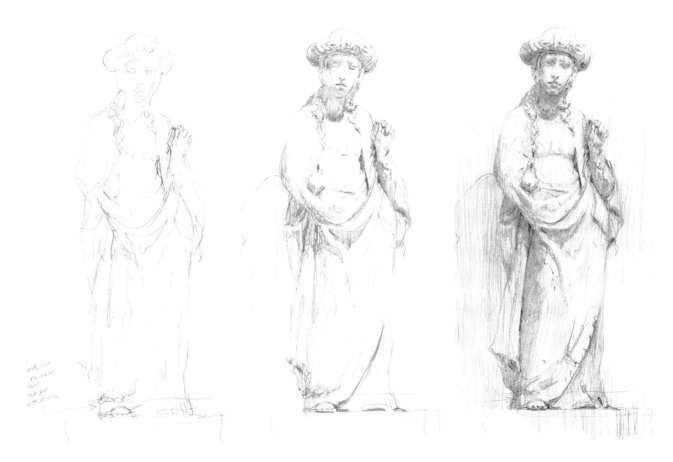

Line Only

If we compare a completely linear drawing, with one that includes shadow shapes you can see immediately how the illusion of depth functions.

Shadow Shapes

Create solid form by drawing the inside contours of shadow shapes right on top of the silhouette. Simply outline the dark shapes you see wherever an object turns away from light. Note where small ridges and overhangs cast linear shadow shapes, or where concavities make holes in the surface. Some of the most descriptive shadows are the places where two things touch—where an arm rests against a body, or where something sits on the ground. These smaller shapes are called *contact shadows*. Drawing accurate shadow shapes is one of the key concepts you'll apply to sketching in ink and later in color, the ability to see the pattern of darks that describe an object's structure, and render them with graphic clarity.

Fully Rendered

To complete the illusion of depth, we only have to blend the light and the shadow shape together with gradations of half tone and perhaps a few indications of surface texture. Simply "grow" the shading outwards from your simplified shadow shapes to blend your graphic shadow pattern smoothly into the light. This is what the pencil can do best. The tiny tip of a mechanical pencil excels at gradually building up value. This shading in with greater and greater density of small marks is the kind of pencil sketching everyone is familiar with. It's relatively easy to get lighter or darker tones by varying your pressure or how much time you spend building up an area. With even the briefest experimenting, this should come easily. The mechanical hand-skills of pencil shading are not nearly as difficult to master as the ability to clearly see shadow shapes.

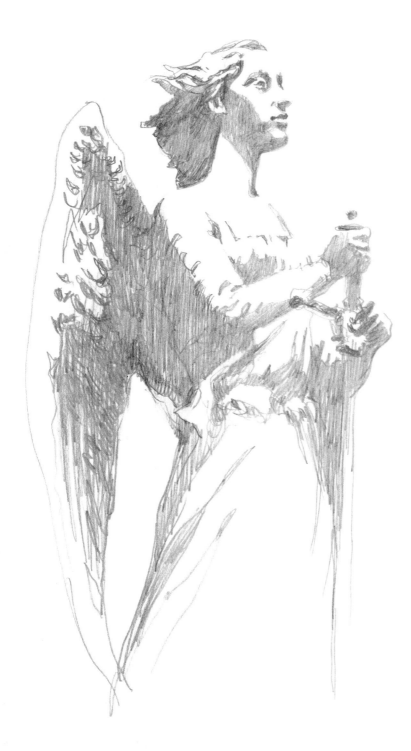

Practical Concerns

If you're drawing in public for the first time, you may feel self-conscious at first. This is something every new urban sketcher feels. If you just concentrate on your sketch, you can quickly overcome any nerves.

Consider going with a friend or two. This is what makes clubs so popular. Sketching in a group frees you from that social awkwardness. The added bonus is that it helps motivate you to sketch—at the end of the day you have to have something to show your friends.

If you're sketching at a business or on city property, occasionally someone official might come by and ask what you're doing. I always show them my sketchbook and say, "I'm an art student. I hope you don't mind if I get in a bit of practice drawing." Most people are fine with this, especially if you're willing to show them your sketches.

Inevitably though, you will encounter someone who is not happy with your presence, particularly if you're in a place with security concerns. If anybody actually says, "You can't do that here," don't react negatively. Just be upbeat, smile and thank them for informing you. Close your book and leave immediately. If you go in with a plan for handling this type of situation, you won't be thrown off or get defensive deciding how to react.

Shadow Shape Study: Cemetery, Havana
Consider a trip to the cemetery. That might seem like an odd place to sketch, but a graveyard is full of sculptures, making it an ideal place to practice sketching shadow shapes.

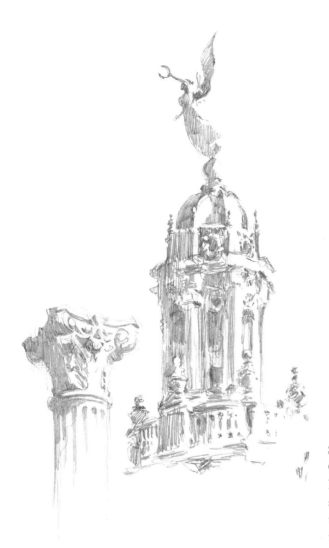

Shadow Shape Study: Architecture, Havana
On a sunny day you could make a visit to a cathedral or opera house—anyplace with the kind of deeply carved, classical architecture that casts interesting shadows. As you scout locations, look for decorative relief carvings in strong sunlight—these make for good practice drawings.

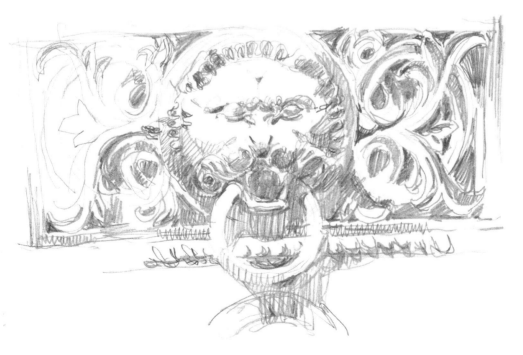

Demonstration

Create Bold Shadow Shapes

For the purpose of training the eye, we will over-emphasize contrast in this sketch, creating bold, intensely dark shadow shapes. If you're a beginner, it's best to take as many sketches as possible up to step 2 while on location. Then you can choose a few favorites and refine the shading at home or over coffee in the museum cafe.

Materials
sketchbook

0.7mm mechanical pencil

kneaded eraser

1 Begin with outside-in sketches; it's still important to have a framework.

2 Concentrate on seeing the shadow as a graphic pattern. Once you have the most general outline (just a carton shape), rather than adding details with line, begin building up the shadow areas.

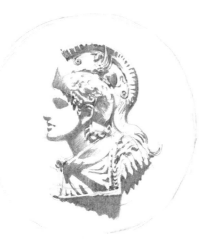

3 Continue shading in the shadow shapes as a solid mass of dark.

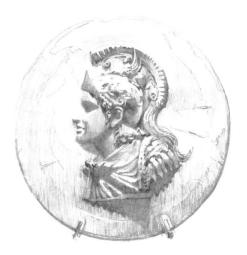

The Finished Sketch

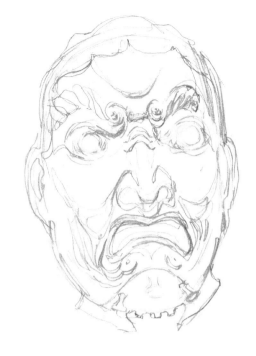

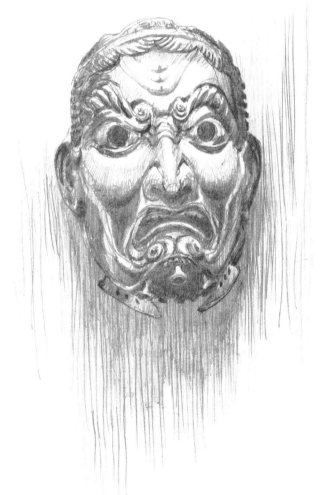

Work Quickly!
You'll learn the most by doing a lot of these exercises quickly. If you can spend a few hours on location, try to do three or four pages of 10 or 15 minute studies. Try to quickly break down what you see into two distinct tones.

Don't forget to sight measure to be confident you have a good outline before you dive into placing shadows. Do a POV check every so often to see if you're getting a nice rendition of your subject's value patterns.

Composition & the Gradient of Interest

Now that we have something of a system for drawing individual objects, let's talk about composition. Composition, simply put, is the overall design of a drawing. It's how our sketchbooks tell stories to the viewer.

Some sketchbook spreads will be collections of objects drawn at different times and places, a with no fixed point of view or scale. This is called a *montage*. Other sketchbooks will show a scene in a natural, photo-realistic manner. You might call that a *view*, simply drawing what you see in front of you.

Both kinds of drawings are absorbed by the reader in the same manner. People view artwork in the same direction they read text—left to right for Western language readers, and top to bottom for Eastern language readers. We tend to conflate the eye's progress across the drawing with progress through time. As objects are encountered on the page, a story forms in our minds. Any sequence of objects automatically becomes a narrative, a guided tour.

I like to sum this up in a principle I call the *Gradient of Interest*: All of the elements that attract the eye, the highest detail and greatest contrast, should be combined at the compositional focal point and fade away smoothly towards the edges. Whatever aspect of the sketch is most important to you needs the greatest intensity of these three factors: placement, contrast and detail.

In a larger drawing there may be secondary or tertiary areas of interest, which lead the viewer like a trail of bread crumbs. But none should be powerful enough to compete with the gravity of the focal point.

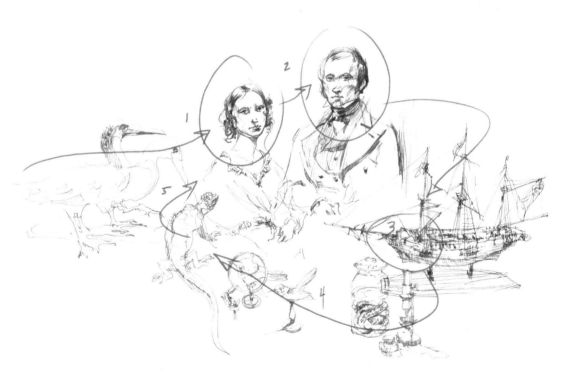

Eye Tracking

Let's take a moment to analyze how the eye reads this sketch from a Charles Darwin exhibit at the Maritime Museum in Barcelona. As the eye travels left to right, you're immediately drawn to the characters faces—they're the most interesting. It's not necessary to draw their clothing in any detail. The fabric is simplified into impressionistic scribbles because it's just not important next to the portraits. Next, your eyes likely can't help continuing down to the interesting model ship (attracted by all the tiny detailed shapes). Then your attention circles back around through the small objects and returns to the faces.

Visit artistsnetwork.com/theurbansketcher to access bonus lessons.

Placement, Detail and Contrast Help Control Viewers' Interest

You must plan the placement of objects on the page to appear in the correct order of events. But there are other elements you can use to control the viewers' interest.

One of these is detail. Every drawing has areas of informational value or unusual density of activity. Any tightly grouped small shapes will hold the eye. We are most attracted to people's faces, followed by symbols—designs, patterns and ornaments.

A second factor is contrast. The human eye is greatly attracted to areas of high contrast. This is sometimes described as *visual weight*. Dark shapes are called *heavy,* describing their attraction, pulling you in, almost like gravity. Edges where the brightest light and darkest dark meet with a sharp line are the most attention grabbing. (I call these areas where contrast and detail overlap *eye magnets*.)

It's this combination of placement, detail and contrast that we call composition.

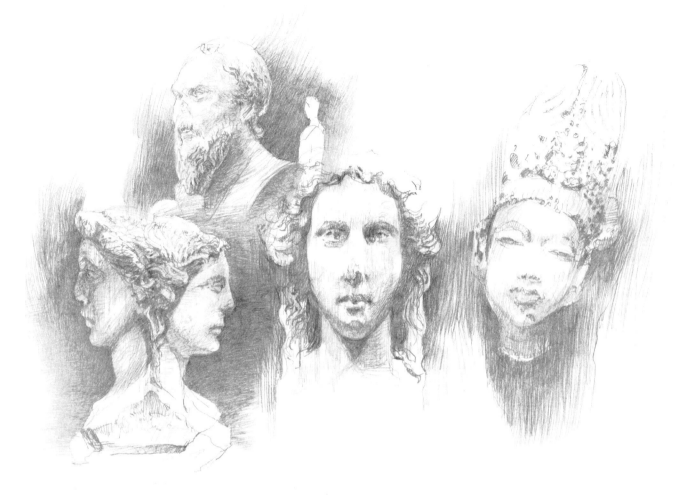

Spend Your Time Where It Counts

In this sketch of classical sculptures at the Musée des Beaux-Arts in Montréal, notice the way your eye jumps from face to face, skipping over the neutral dark tones in between them. The central placement of the woman's head and the dark pools of her eyes probably grab your attention.

Just remember, the areas you spend the most time on will also be the areas people spend the most time looking at. Simply focus your own attention in the same places you want the viewer to focus. Restrain yourself from putting unnecessary effort into other areas. Don't overwork things, but give yourself permission to leave areas outside the focus unfinished. It makes the sketching process faster and frees you up to draw only the fun parts.

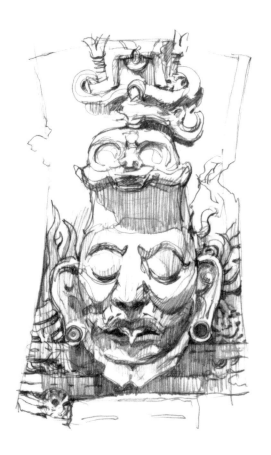

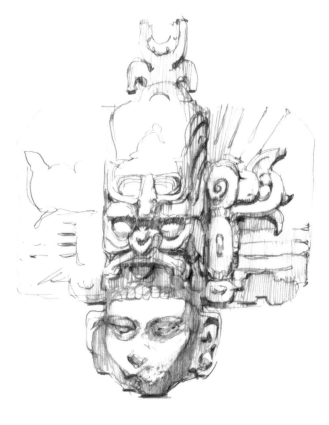

The Gradient of Interest Principle in Practice
Even when sketching a single object as opposed to a scene, you can use the Gradient of Interest principle to good effect. These examples of Mayan terra-cotta sculpture from the Museum of Civilization in Ottawa show how it can work. By suppressing detail away from the focus, and stacking the darkest darks and greatest detail on top of the important areas, you can control the movement of the viewers' eyes.

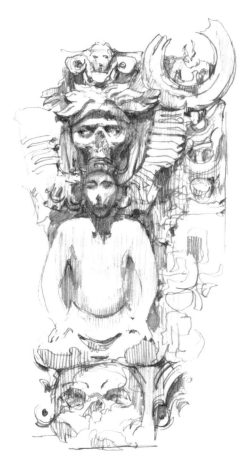

Demonstration

Guide the Eye Through an Object Montage

. .

This exercise will require a variety of nicely lit objects, so perhaps another museum expedition is in order. It's up to you. (I'm a big fan of museums, but by now you might be thinking up a list of your own drawing spots.) Wherever you end up, take a quick scan of what's around and choose the things you'll sketch. For each of the spreads you do, choose the "rock star" object—the focal point. It's likely you'll draw this first, larger and in greater detail than the other objects.

Materials

sketchbook

0.7mm mechanical pencil

kneaded eraser

1 Approach the page design by quickly sketching silhouettes for everything you wish to draw. Roughly place each of the objects. Remember to check relative scale and positioning.

2 Complete the outside-in sketches for your montage of objects just as you did in Exercise 2, but this time add in the shadow shapes.

3 At this point, "Saint Jorge slaying the dragon" attracts the strongest attention. But you can easily move the emphasis by rendering the wood carving of the preacher with even greater contrast and detail.

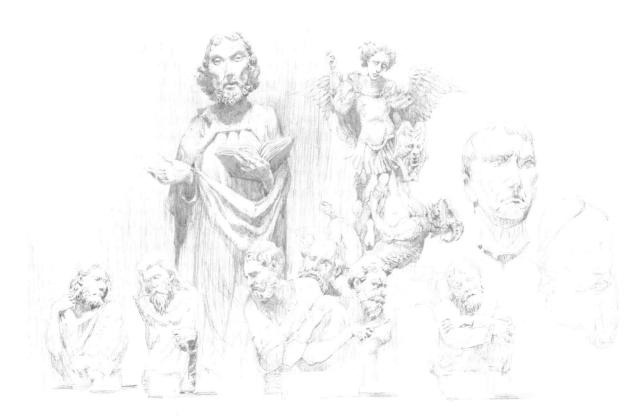

4 Once you've established your primary object with the highest degree of finish, keep blending the gradient of interest towards the edges. Consider using a background tone to emphasize the focal item with even more visual weight. You should feel the gravity of the most rendered object pulling attention towards itself.

Just remember, if you put less energy into drawing secondary subjects, the viewer will also put less energy into looking at them. Once you start using this strategy, you be able to direct the viewer's eye to whatever story you're telling. You can make stronger page compositions with less effort.

Exercise 3

Strong Focus in a Street View

It's time to finally head out for some street sketching! Sketching a street scene is not that different from sketching a montage. You're still picking and choosing from a variety of objects, but now you're letting the real world suggest which are important and where to place them in the composition.

Moving outside can raise many distractions. In addition to the weather, the noise and the street traffic, you also have the complexity of an urban setting to deal with. To get street drawings with the same clarity as more sedate cafe and museum drawings, you need to simplify reality. Subtract all the extraneous detail and concentrate on the focal point. Use the gradient of interest principle to pull a strong composition out of all the street noise.

Rely on all the techniques we've covered so far—drawing outside in, sight measuring and seeing shadow shapes. All of these concepts should work together.

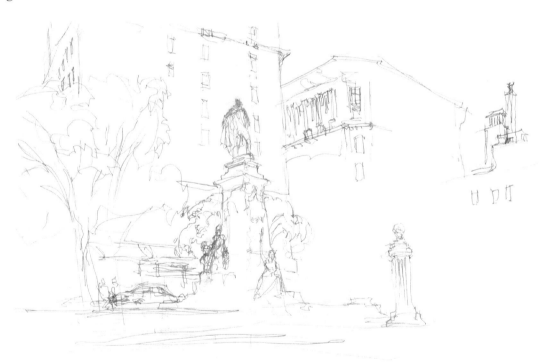

Start With the Main Subject, Sketching Outside-In

Remember to start near the center of the page with plenty of room around. Sketch the main silhouette, working outwards in a spiral. If you see any secondary areas of interest—trees, signs, lamp posts or interesting parts of the background—go ahead and sketch them in, making sure to fade off the detail towards the edges.

Find the focal point first and ensure that everything around it is part of the Gradient of Interest. By starting with your focal point first, you ensure its placed front and center with plenty of

room to lead the eye towards the climax of the story. This is a no-fail formula for a well composed sketch.

Don't try to capture everything. Suppress detail as you move away from the focal subject. Only draw the most interesting bits. (In this case, I left out most of the clutter in the square, including a gazebo housing some kind of vendor and an overly complicated bike rack in the foreground that would have competed with my subject.)

Visit artistsnetwork.com/theurbansketcher to access bonus lessons.

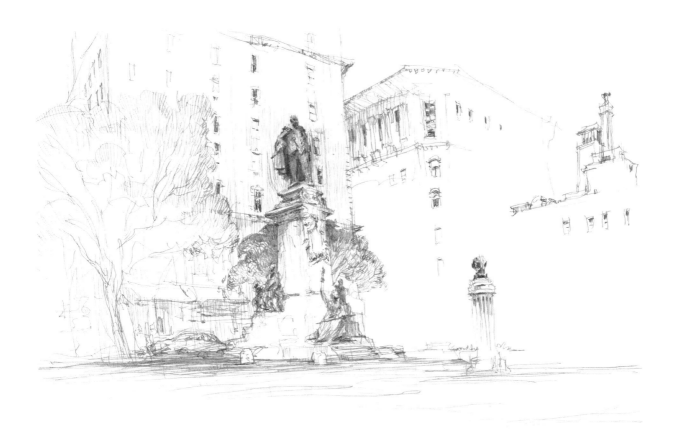

Establish the Gradient of Interest

The real world is simply too complex to capture everything. You must intentionally leave out information, turning peripheral things into mere silhouettes or unfinished scribbles to ensure your focal point gets all the attention. You want your focal point (here, the statue) to be the most detailed object in the scene, rendered with the most solidity to establish a clear gradient of interest.

For now, leave people out of your sketching. Eventually you'll want to get to that, but it's not unreasonable to omit moving targets, especially if you're just getting started with drawing on location. (We'll cover drawing people in motion in a later chapter.)

Anchoring the Scene

Find a view with a strong central focus—a public square with a fountain or statue would be ideal. The monument in the center of the square can be treated as a kind of urban still life. Other scenes and subjects that work well are ornate entrance ways and towers or domed rooftops, which can be isolated against the sky. These kinds of strong focal points will allow you to anchor a scene.

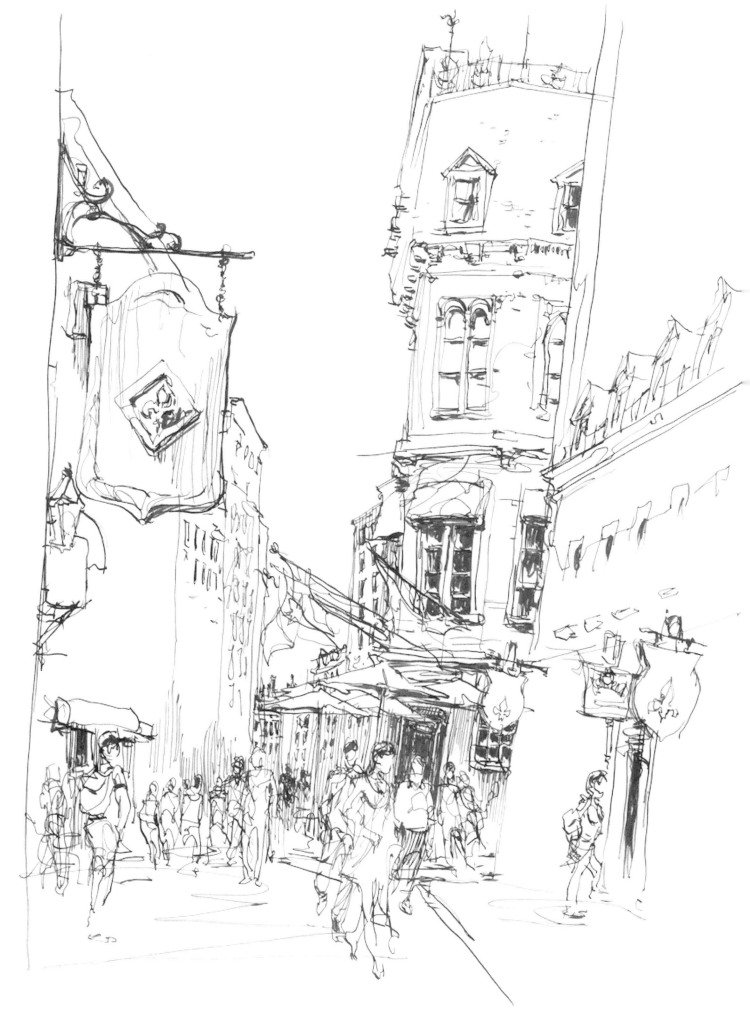

CHAPTER TWO

Pen & Ink: Expressive Lines, Powerful Contrast

· ·

Pen and ink is where sketching gets really exciting. Pencil is forgiving, very flexible. Once you move to ink, you'll have to get comfortable with committing. In this chapter, you'll learn a pen and ink approach designed to make you as prepared as possible. No matter what, though, eventually that black line has to go down, and it's permanent when it does.

That's exactly what makes ink so amazing—the stark blacks you achieve so easily, and the fluidity of the frictionless liquid line. It's speed and directness allows greater freedom of expression. After the subtle rendering of pencil shading, ink will feel like your drawings are shouting out loud. There's nothing tentative about it. Especially if you're drawing with a brush.

Ink drawing is my personal favorite medium. It's just so much fun and so perfectly suited for impressions in the field. You can have a finished drawing in mere minutes.

Key Concepts in This Chapter...

- Three-Pass Sketching: Learn to quickly get a complex scene down on paper with a three-step approach that is the optimal balance between speed, accuracy and expressive line work.

- Drawing People in Motion: Take on the most interesting and challenging kind of visual storytelling—capturing the action of people in motion around you.

Pen & Ink Tools

There are a wide variety of ways to make ink marks, ranging from the precise calibrated line of drafting pens, to the total simplicity of dipping a twig in a bottle of ink. (Okay, I've never tried that, but there are sketchers like Kiah Kiean of Penang, Malaysia, who get great results with twigs).

You'll want to explore, try a variety of things. A nice pen is very much a personal preference. Here are some of my favorite ink tools:

- **Paper.** In general a smoother, coated paper is better for ink. You get sharper lines and darker blacks. You might consider a smooth-finish Bristol such as Strathmore series 300 (available in pads), or a book with smooth stock such as the Stillman & Birn Epsilon. The well-known classic Moleskine sketchbooks with their heavy, waxy coated stock are also great for ink, if a little on the smallish size.

- **Ballpoint pens.** Nice because of the smooth, uninterrupted drawing. They have a zip to their line. I don't even mind when they blob a bit of ink, but better brands won't do that.

- **Fountain pens.** I like the Lamy Safari. They're affordable, and come in a variety of sizes. I will say the name brand Lamy pen cartridges are not waterproof, in case you one day are putting washes on top. I actually enjoy that effect, using it to my advantage when doing line and wash. (*See Bonus Exercise #20: Water Soluble Ink*).

- **Dipping nibs.** Buy a pen holder so you can try a variety of nibs in it. Each type has slightly different response to pressure and can make a different shape of mark. If you look on calligraphy websites, there are many varieties of nibs to try, most of which are inexpensive. I like the Hunt #22 nib, but I encourage you to try a variety of manufacturers. Each has its own "springiness" and ink capacity. I also use Japanese G nibs, which have a nice range of line quality.

- **Brush pens.** I like The Pentel Pocket Brush, and the Kuretake #13. These are cartridge-fed pens similar to a fountain pen. These nylon brushes (with actual fiber "hairs" are vastly superior in line quality

Fountain Pens
I use the use a Lamy fine and extra fine nib, but also their 0.9 chisel nibs meant for calligraphy. They use disposable ink cartridges, which are very convenient for travelling. Or, you can get a third party refillable cartridge device.

Dipping Nibs
Dipping nibs give you a tremendous range of line width controlled by the pressure, speed and angle of your stroke. They have a more expressive line than fountain pens. Plus, you can change the color of ink on the fly.

and durability over the rubber tip found in cheap disposable brush pens.

- **Ink and water bottles.** I use Nalgene brand bottles, which you can get in small 1 or 2 ounce sizes at backpacking suppliers (meant for pills or lotions). They are sturdy and totally watertight. If you're carrying ink in your bag every day, a reliable bottle is worth looking for.

- **Natural brushes.** I carry about five round brushes in sizes ranging from nos. 0 to 20, depending how large I'm drawing. I don't use flats as I always want to be able to draw with the tip of a brush. Natural sable hair brushes are best, but the most expensive. They hold more liquid, have a sharper point (even at larger sizes), give a better thick-to-thin stroke, create better drybrush texture, and they last longer.

- **Synthetic brushes** aren't quite as nice, but are tremendously less expensive, especially at a larger size. I mention this because eventually you'll drop a nice brush down the sewer grate, so, you might not want to carry pure sables around in the field.

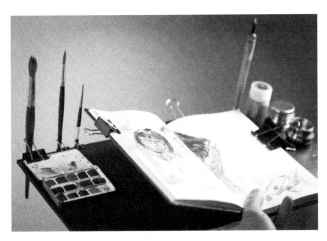

Palm Desk Setup
The palm desk setup works well if you feel you need to have a few more supplies with you when drawing.

- **Travel brushes** are collapsible and come in various designs. The Da Vinci Maestro series are the best travel brushes I've found. They come in synthetic or natural sable and are sturdy enough that you can safely toss them in the bottom of your bag. After any extended use, leave them open overnight and let them dry out naturally to prevent any corrosion on the ferule.

- **The Palm Desk.** This is just a fancy way of describing a small board or piece of Coroplast® tucked under your book. Clip your gear all around the outside edges. Some people attach magnets or use that tacky poster-hanging gum to stick on an ink bottle. You can balance this contraption on your hand or knee, or if your backing board is large enough, you can tuck it against your belly for support. (I've also used it mounted on the end of a monopod, when I knew I would be walking through a crowd for hours with nowhere to set things down.)

Logistics

When going out to draw on the street, you have to think about logistics. How do you actually get around with all your gear? Usually I carry everything in a shoulder bag for easy access and just hold my sketchbook while I walk and draw. I've done sketches without completely stopping walking. You just kind of meander, and get some lines in every time you stop at a traffic light, or while your friends are trying to figure out where the restaurant is.

I prefer to stand while working, though sometimes you can find somewhere to lean against, or put down your ink and brushes, anearby window sill, a mail box, whatever is around.

I will hold sketchbooks open with binder clips to keep the pages flat until dry. (Put a few big clips on each side grabbing the whole block of pages, including cover). This is a good idea in general as the wind is always flipping pages on you.

Three-Pass Sketching

Three-pass sketching is the ideal method for drawing real places and actual events as you experience them. Of course, there are as many ways to draw as there are artists. But this systematic approach is the best balance I have found between accuracy, spontaneity and speed.

Every artist who is attracted to sketching will say they love the freedom of drawing swiftly and expressively, the pure joy of a lightning-fast sketch. At the same time, it is a common regret that the final result doesn't always look enough like the subject.

Speed of execution is also a primary concern for the urban sketcher. When you're on location, the clock is always ticking. I'm sometimes overwhelmed when choosing a view to draw. Picking this subject, means not drawing that one. This desire to see it all and make art out of it—it's the most noble reason for wanting to draw as fast as possible.

So how do we accomplish this three-way balance? The main concept behind three-pass sketching is to separate the logical work of observational drawing from the intuitive joy of artistic mark-making.

Accuracy. All the planning and measuring is completed in the pencil stage. By drawing outside in, sight measuring and angle checking, you can make sure that proportions are correct while you are still able to erase. By sketching shadow shapes, you plan a map of values for later use.

Spontaneity. When you commit to the permanence, the bold expression of the ink, the thinking part is over. Draw with confidence, making sweeping, expressive lines without any concern for the anatomy of the subject.

Speed. This is where pen and ink comes into its own. Black ink has much greater visual weight than pencil shading. With a brush and ink, you can lay down inky black shadows with speed and authority, instantly transforming a drawing. It's like turning up the volume. Do you recall how long it took to accumulate depth with the pencil? Well now you can pour on the darks!

In this way, we achieve the balance we're after. You don't need to worry about artistry in the first pass, and you won't have to struggle with accuracy later. It's a perfect division of labor. These three passes might seem more complicated than the gradual buildup of pencil sketches, but with practice, you will become very efficient at each step. Each pass should build on what went before. Be careful not to overwork your sketch—draw only as much as is required. The whole process might be completed in 10 or 15 minutes for a simple subject, an hour or two for a more complex street scene.

The following pages will walk you through a few examples of three-pass sketching and examine each part of the process more in depth.

Break Down Architectural Details Into Component Shapes
This fanciful entrance way with its Corinthian columns and deeply carved pediment might look like lot of detail at first, but It's really quite simple once you break it down into component shapes.

 Visit artistsnetwork.com/theurbansketcher to access bonus lessons.

First Pass: Contour Sketch

I often call the graphite under drawing the *scribble,* or *the capture* (when referring to drawing people or animals). The goal is to make a loose, sketchy contour drawing working from the outside in. You can also make note of interesting details for later use.

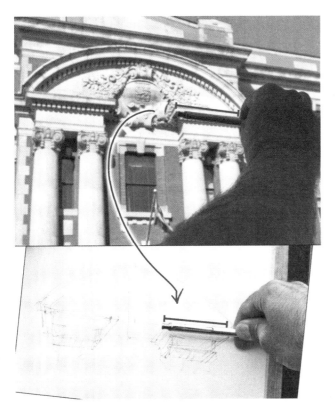

Sight Measuring

The pencil drawing is not intended to be the finished work. It's only the measurements for the more expressive ink drawing to follow. You don't need to be cautious, you won't be keeping this drawing. So work quickly, sketching diagrammatically, without concern for elegant line work or perfect detail. Scribble in shapes. If you misplace a bit, just correct right on top. Don't even bother to erase the other line. It doesn't have to be well drawn. It's only the guide for later.

Pass One: Contour Sketch in Graphite

A structure like this should be drawn from the outside in, just as you did with the still life subjects previously Deconstruct the architecture into its biggest forms first. Do just enough drawing that you can sight measure or POV check the scribble and establish that everything is ready for ink. Pillars, capitals, arches—try to see everything as just a stack of shapes.

Second Pass: Calligraphic Line Drawing

Once you have a satisfactory scribble, you can concentrate on making a beautiful ink drawing on top of it. This is a wonderfully freeing stage, as you're not thinking anymore. The work is done, and play begins. Just get into a zone making beautiful pen marks. With the pencil, you probably found yourself gradually building up marks. It's a bit slow, meditative. With ink, it's more swift and decisive. Now that you are drawing over a guide instead of trying to get it in one go, strive to draw with authority. I like to draw standing up, using the whole body, not the wrist.

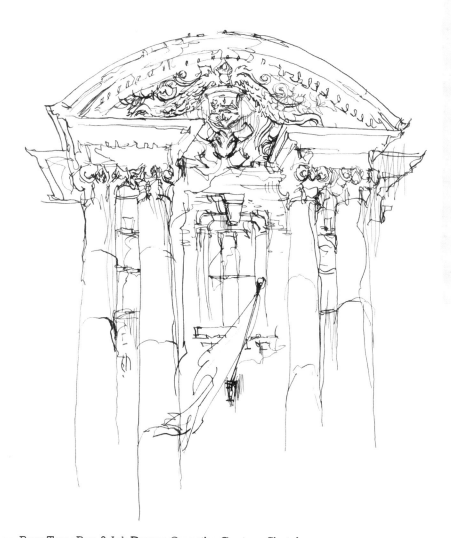

Pass Two: Pen & Ink Drawn Over the Contour Sketch
Make your line work calligraphic, fluid, rhythmic. Not rendering mechanically, but making shapes and impressionistic marks which describe the subject elegantly. This is also the time when you can dive into the detail that everyone loves to look at. All the little shapes inside ornamental details, all the chips and cracks in a weathered surface.

Sketching in Ink Sharpens Painting Skills

· · · · · · · · · · · · · · · · ·

For the first few years I was exploring urban sketching, I worked exclusively In the three-pass manner, using ballpoint and brush pens to create high contrast sketches. Only later did I begin painting over top of my drawings. I was not aware of it at the time, but the investment in drawing boldly with ink, as opposed to the gradual shading done with a pencil, was instrumental in training my painting skills.

Visit artistsnetwork.com/theurbansketcher to access bonus lessons.

Third Pass: Spot Blacks

In the third stage of this sketching method, use a brush and ink or a brush pen to place solid black brush marks into the shadow shapes. (If you find drawing with liquid ink to be awkward at first, just stick with a brush pen for a while. It gets easier after a few hours of practice.)

Well placed spot blacks instantly create visual focus. Recall how you established a gradient of interest in the still life sketches by choosing which objects would get both contrast and detail. With spot blacks, you are doing the same thing but with much greater power.

This step can go very quickly. If fact, it's easy to let yourself go too far too fast. Where previously you were carefully building up shadow shapes with pencil shading, now you'll be able to rapidly fill them with fluid, inky strokes.

After laying in the darkest dark shapes, feather the shadows into the sketch with some rapid hatch marks in ballpoint or dipping pen. This will soften the transition from the shadow shape into light. After the dust settles, give the ink a few minutes to dry, then go in with your kneaded rubber eraser and lightly remove any remaining pencil that shows through. This should be like lifting a veil off the drawing. It will look crisper and the contrast will pop.

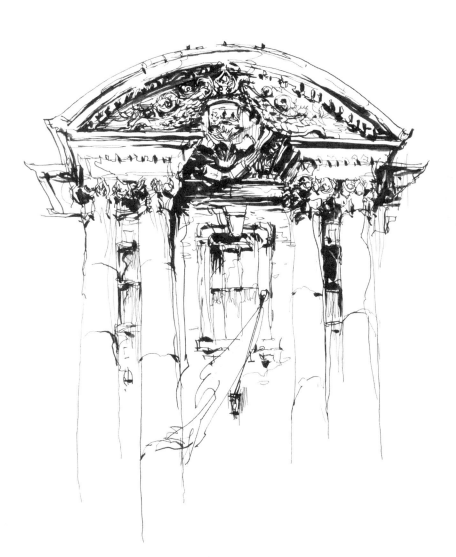

Pass Three: Spot Blacks Over Pen & Ink
When spotting blacks, you must judge carefully where to place solid darks. In reality there may be shadows in compositionally inconvenient places. But high contrast is so visually powerful, you must control where you use it. Every black spot is an artistic decision about where the eye should stick.

Not a Fan of High Contrast?

Every one of these three-pass sketches is training for the future. The skills involved in seeing masses of value and putting them down with direct, solid brushwork are going to pay off later.

So even if this amount of contrast is not for you, try it out a few times. If the contrast is too strong for your taste, consider using ink diluted with water to spot-black in gray, sepia or other tones. Or you might look for brush markers in shades of gray or other neutral colors. This will give a softer effect, while still giving you the training you need.

Progression of a Three-Pass Sketch

Here is an example of my progression through a relatively complex street scene. But by working in three passes and drawing outside in, the challenge was broken down into manageable chunks. For this sketch, I stopped by a stretch of Rue St. Denis in the Latin Quarter of Montreal.

On this particular corner there is an excellent example of one of our brick and stone, three-story multipurpose shops featuring the kind of conical tower that I love to draw, as well as an interesting wooden balcony. At the far end of the block, you can just see a silver cupola rising above the street, part of a monumental old hospital.

First Pass: The Scribble

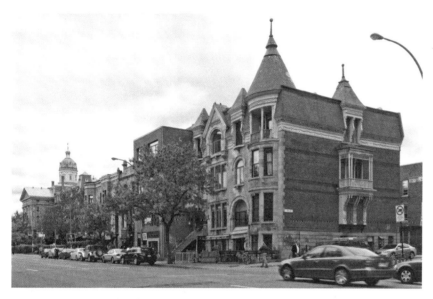

Establishing Shot

Sight Measuring
My goal for the scribble is to accurately measure the buildings on the block. I leave the foreground open, waiting to see whatever interesting activity might come along. This is probably just going to be normal pedestrian traffic, but you never know.

Perspective Lines

The very first thing is to draw the diagonal lines of the roof and the sidewalk, using an angle check to find them. This is the basics of two point perspective. It doesn't much matter if you haven't studied the theory behind it, as long as you keep in mind all the horizontal lines in the building fall between these two easily measured diagonals, arranged radially, like the ribs in a paper fan. These lines are the container. Everything you do from this point is attached to these guidelines. You only need to angle check the roof line and the sidewalk, then use these two diagonals like the scaffolding on which you'll construct the buildings.

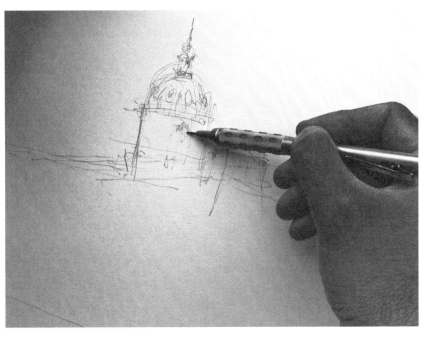

Subdividing

I move on to subdividing the frame created by those perspective lines. At this point, I should be rigorous about working from bigger shapes to smaller ones, but what I actually draw first is the distant silver cupola.

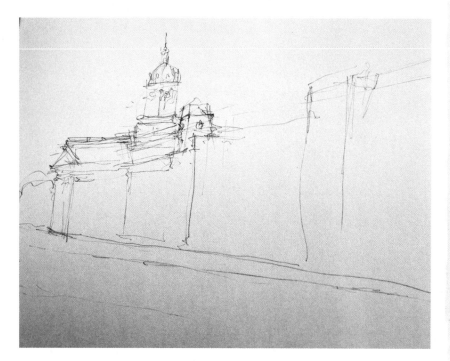

To Err Is Human
.

After sight measuring the two important diagonals I went straight for the silver cupola. I couldn't resist doing this detail. Halfway through scribbling in the block, I realized the dome I drew was placed incorrectly. I could see that its base should have been higher compared to the bay window next door. It was also too short and stubby. I had to erase the entire thing and re-drew it in a more accurate position (shown in Step 3). I should have followed the three-pass system and not made a nice drawing of that part too soon. But it's only a scribble, so I happily made the change.

Buildings Blocked In

I start to build the block by subdividing the perspective lines into the verticals that mark the buildings. I roughly sight measure the building widths but am not concerned about accuracy in the middle of the block. It's just a passage between two areas of interest. There is one boring cube-like building in the mid block that needs to be squeezed down to de-emphasize it's dullness. I used some artistic license here and cover most of the middle with trees and objects.

Angle Checking and Big Shapes

When I get to the end of the block, I'm at the star attraction: the corner building with the conical tower. I get the big shape first by angle checking the roof where it changes direction and creating the box I'll work within.

More Subdivision

Next, I start to cut the main building up horizontally, like a wedding cake. It has three and a half floors (the street level is one of those half floors that drops below the sidewalk). I mark where each floor ends with a quick dash, then proceed to divide the stories into window bays. I check where each of the peaks touch the roof line, telling me where to drop

verticals to place the windows in their stacked columns. It becomes a tic-tac-toe grid in perspective across the frontage. I pop some shapes in there to roughly indicate windows, ledges, trim and panes. It's interesting—as you draw, you discover how the building is constructed.

Drop Verticals

The process is repeated on the side wall. I mark where the peaks hit the roof and drop verticals from there. This shows me how to easily draw the balcony. A final point of view check is a good idea before calling your scribble complete.

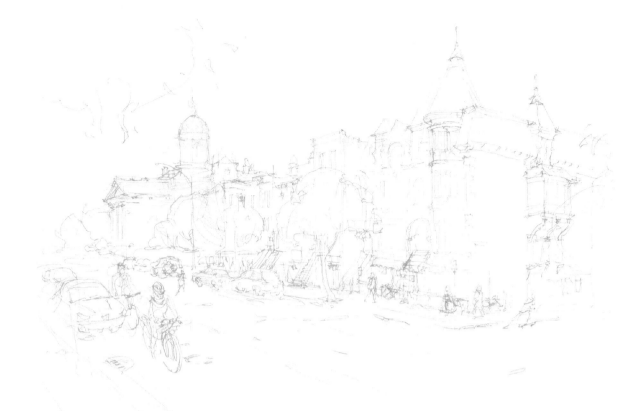

Completed Scribble

Don't Document—Design

As much as I harp on sight measuring, accuracy isn't everything. We should find our own balance between accuracy and spontaneity. I have a personal motto: Don't document—design. Don't just draw what is in front of you. Design what you put down in response to what you see. There may be valid reasons for you to alter strict reality to match your perception.

Your first goal should be to make viewers feel what you felt at the location, then to draw their attention to the specific elements you were fascinated by. It's only a (close) third in importance for people to recognize the place. To get that personal response to the drawing, sometimes you'll have to make intentional "errors."

It's acceptable to move a tree, or car or signage in order to reveal an important detail or to cover a distracting area. That's fair game. I'll draw the impression of details like carved moldings or serrated edges—not a blueprint of the building. You might also want to make a building a little more elegant, or add some wide-angle-lens curvature to real perspective, bringing more of the world into view.

Personally, I often leave out distracting background elements, drawing architectural subjects with a clear silhouette, leaving out the city behind so the subject can be seen against clear sky. And I always consider suppressing detail toward the edges of my sketch so that the eye is not drawn away from my focus of interest. I try to do this all in good faith, not altering a scene any more than is necessary to tell the story as I experienced it.

Second Pass: Calligraphic Line Drawing

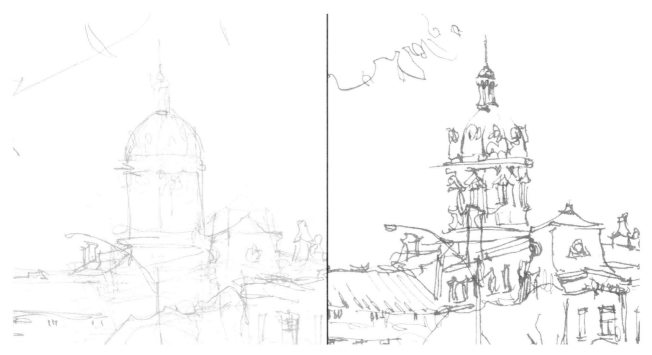

Cupola, Before and After

I prefer not to draw details, but to create impressions. It is impossible to see every brick or bit of carved molding when looking down the street.

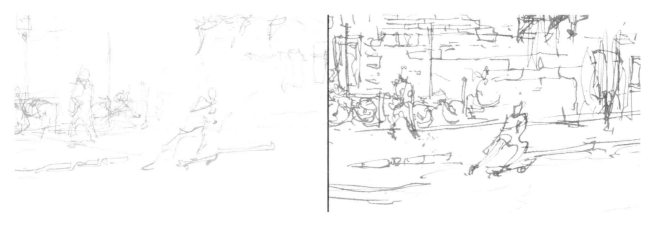

Skater, Before and After

Lines in a sketch should be open—small breaks letting light into the form, not closed outlines around objects. At times line work can even wander outside a form to integrate it with the environment around. Leave some things to the imagination. Suppress unnecessary detail. In a crowd of figures, you can't really tell which legs belong to whom. Let forms merge and reduce the unimportant details while exaggerating what tells the story best. Allow the viewer to read the sketch and interpret the shapes. Just like the impressionist painters, your marks combine to form the objects.

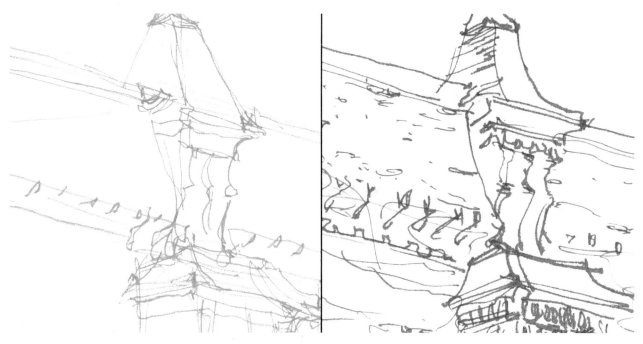

Gables, Before and After

I use varying line weight to suggest shadows underneath overhanging forms—things like brickwork, window ledges or foliage. Draw the shadow shapes, not the things casting them.

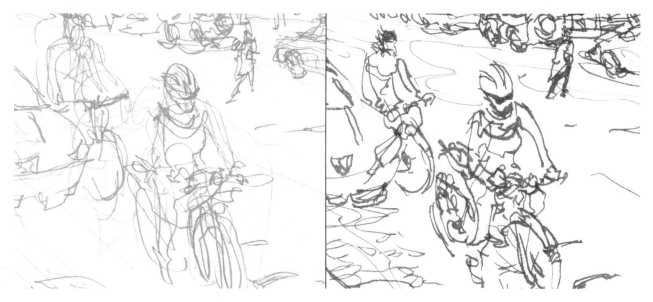

Cyclists, Before and After

Strive for your own personality in your line work, not bland perfection, but do your best to avoid scratchy, searching, hesitant lines that come from repeating a stroke over itself multiple times. A line should have expressive character that looks intentional, not stuttering, but speaking eloquently. Look for opportunities for interesting line—rhythm, repeating scalloped curves, not-quite-parallel hatching. Consider using open looping squiggles that cross forms.

Hatching

Anything goes with the marks the pen can make. The only thing I caution you to avoid is crosshatching—regular patterns of line that cross each other at 45 or 90 degrees. That method can build up controlled gradations of tone, but it's very mechanical. I don't like to add anything that might stiffen up a drawing.

I find free-flowing lines come naturally when drawing on location. You are frequently uncomfortable, standing for too long, enduring the weather, or hunched over a small stool juggling art supplies. Harness the natural desire to rush. Let impatience give life and energy to your lines.

At the end of the second pass, I have a drawing, that resembles the scribble, but with much greater detail and refinement of line.

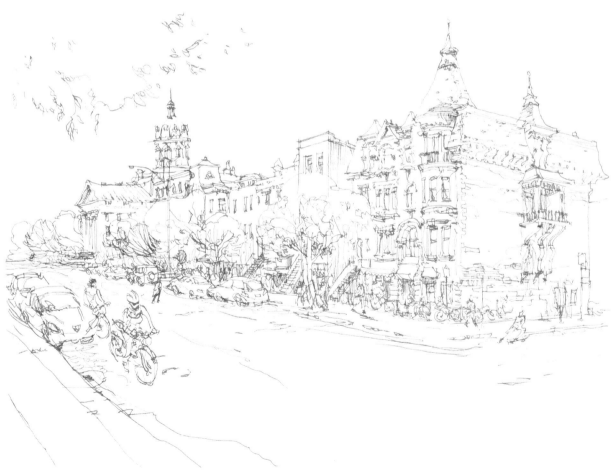

Completed Ink Sketch

Third Pass: Spot Blacks

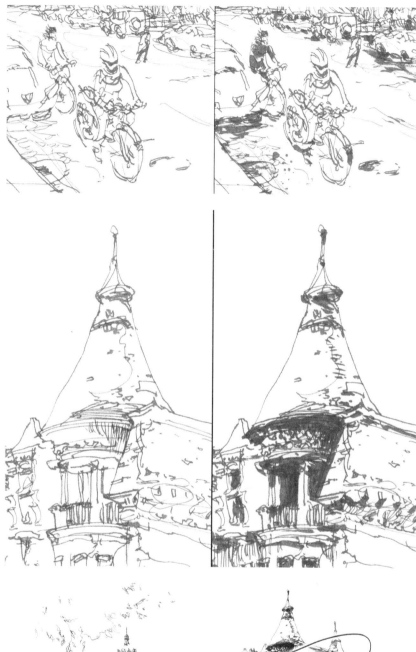

Cyclists, Before and After
In this scene, I want to walk the viewer across the street starting from the left side where I have an eye magnet—the dark bicyclist silhouetted in white. Then following the jaywalking figure, (if I was to paint over the sketch, I would give that little person an eye-catching bright yellow jacket) and latching onto the darks behind the cars, then swept under the strong dark diagonal of the awnings, until suddenly you are at the cafe on the corner of the block, where you have a wealth of interesting detail to enjoy.

Tower, Before and After
Once again, the primary goal here is to guide the viewer's eye to where you want them to look. Organize your gradient of interest using well placed eye magnets. Along the way the viewer may encounter interesting details, but inexorably, they find the focal point.

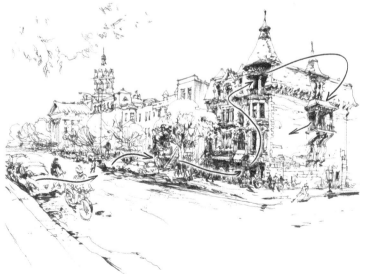

Composition
The gradient of interest should work like a visual tour of the drawing. It's like a one-page graphic novel—the storyboard for a little documentary film on paper. The eye can circulate around all the windows and arches, ultimately landing at the conical tower which drew me to the cafe in the first place. Maybe it flits over to the interesting balcony on the side. My favorite bit, the silver cupola, is there in the distance as a "second read," something you might not see at first, but rewarding to a viewer who gives it a longer look.

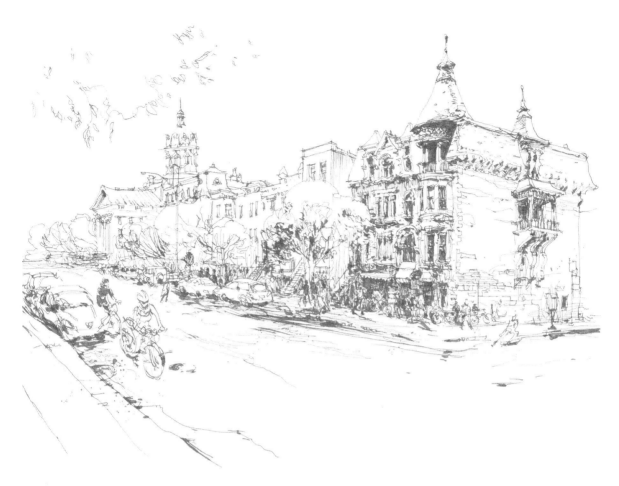

Inked Drawing

A Word of Caution on Photo Reference

Inevitably, there will occasions when you can't complete your sketch on location. Rain is the most likely culprit. Sometimes it's an unforeseen circumstance. Once in Portland, I was drawing the Skidmore fountain, which I did not realize is the center their largest public market. Dozens of workers with trucks, scaffolds and ladders appeared and built a tent city all around me, very quickly obscuring the fountain. The great thing about three-pass sketching is that once you have the scribble, you are in the best possible position to finish from memory. If you have to relocate, try to head to the closet café and finish while the memory is still fresh.

Of course, you can always take a reference photo, but I personally don't recommend drawing from photographs for urban sketching. The viewpoint is fixed, whereas in real life, just moving your point of view a bit to one side or the other can reveal the structure of an object. Photography also does not give you the full range of color and the ultra-wide field of view the human eye has (Unless you have high-end equipment and an understanding of digital post-processing).

Photos can be very useful as an aid to memory, accompanying a scribble made on location. But watch out for the slippery slope. If you are spending more time taking reference photos than you are drawing on location, you're not building up your visual memory. Plus, it's just not as fun! You won't have the opportunity to be surprised by circumstance or by people you meet while drawing. The bottom line is, your visual memory can be surprisingly reliable. Focus on that, not on taking reference photos.

Three-Pass Sketching in Action

Head out in the street and look for interesting objects to interpret into line. The only goal here is to give the three steps a try. I recommend choosing subjects you can isolate from the environment, that you can draw without worrying about perspective or depth of field.

Choose a Location

Head to an a well-established downtown neighborhood, the kind of area that might have civic architecture. Every town has a city hall, and many have civic arts centers or a big cathedral. Frequently it's all within the same district. Any of these places can be great sources of architectural details. (And don't forget that cemeteries are essentially public sculpture gardens.)

Choose a Subject

When I was starting out, I spent months doing these kinds of close-up subjects. Tightly focusing on the things that interest you and leaving out the rest is a great way of reducing the problem of distractions in street sketching.

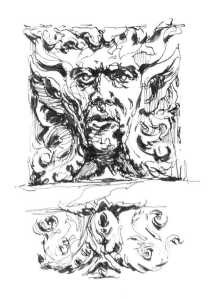

Don't Rush the Process

Remember to use the pencil scribble for its flexibility. Get the analysis right before committing to ink. This gives you confidence to be bold with the calligraphic line. Don't worry about mistakes. Let the scribble be the guide, and if you miss-step, just keep going. At first you might find you prefer your pencil drawings to the ink line. It's natural to be a bit stiff in the beginning. Eventually you'll get the hang of making each layer improve on what went before, not overworking the scribble and not tracing the calligraphy.

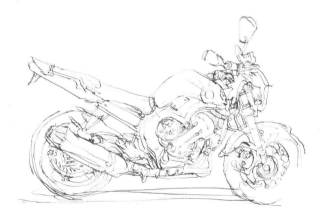
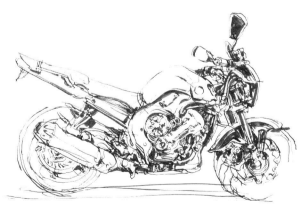

Don't Document—Design

This motorcycle is a perfect example of something I'd once have been scared to sketch. Look at all that complexity! But don't look at detail as an obstacle. Masses of intricate shapes can be fun to draw. There's so much information, it becomes a game to see what you can leave out, reduce to texture or just scribble over. Remember, make your own impression of the thing. Note how the larger forms are clearly visible as big blocks in the pencil sketch. All the small mechanical detail goes inside the shapes set down in the first pass.

Exercise 5
Minimalist Scribbling

This exercise will help re-enforce the idea of the scribble as information gathering and analysis, as opposed to the calligraphic line as the artistic expression. You never want the ink line to feel like busy work. It shouldn't be a chore to refine in ink on top of your scribble. Never approach it like you've already drawn the thing and now you're on autopilot. To that end, practice making the most with the least by doing a completely minimal scribble.

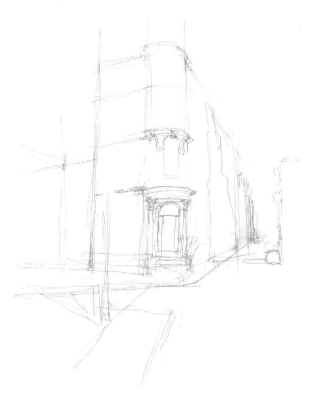

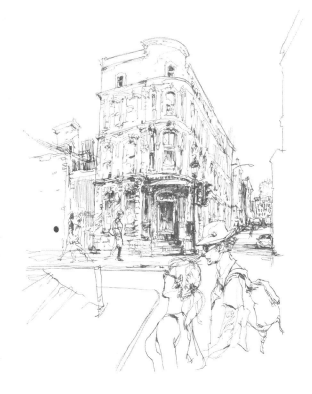

Sketch Only the Minimal Necessary Lines
What are the fewest lines that you can use to establish the structure? How little can you scribble, and still be able to pull off the ink? Would you leave trees as only blank ovals? Could you leave out windows? Perhaps draw cars as just a couple of boxes? Certainly you can leave out rails on balconies. If it's a three story building, all alike, only draw one window and simply indicate the others with a base line. This way you leave yourself plenty of fun for the second pass, which also helps to banish that niggling feeling that you're tracing.

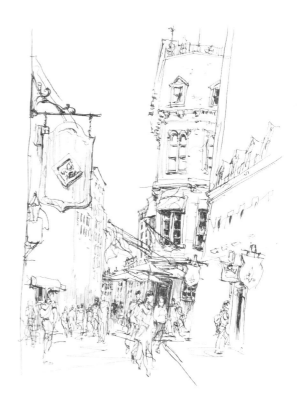

Keep It Quick

Of course, if you do too little, you won't have enough to check measurements and proportion. But if you can find that sweet spot of "the most with the least" you'll be increasing your overall drawing speed. You just have to practice, to make this second nature. I emphasize speed not to stress you out, but because drawing quickly empowers that goal to draw any place, any time. If you can get through all three passes of a sketch in 15 or 20 minutes, you'll be able to take advantage of opportunities that would have previously stymied you. Soon, it won't seem impossible to grab a sketch on lunch hour. You'll be more willing to say, "Give me 10 minutes and I'll catch up with you," knowing you'll be able to use that time.

Stretch Goal: Beat the Clock!

Once you've done this a few times and you're getting comfortable with your minimal scribble, start timing yourself. Give yourself 10, then 5, then 3 minutes to do a scribble. (I use a stopwatch timer on my phone). Tight time limits help you avoid overworking a sketch.

Don't forget to sight measure a few key things, or do a point of view check. Even with a three-minute time limit, it's a good investment of a few seconds. It's worth it to know your calligraphy can go down freely.

Exercise 6
Documentary Sketching Sprint

Touring with a sketchbook is a great way to travel. Looking closely at something, close enough to figure out how to sketch it, forces you to notice every detail, makes you visualize its internal structure. The memories of a city you've drawn are etched deeper, remembered with greater clarity.

This exercise will put you in the mind set of a travelling sketcher. Head to a neighborhood you haven't spent much time in, just a part of your own city you don't often visit, and get to know it through drawing. Depending on your situation, this is also something you can do when on vacation in another city.

Your goal is to fill multiple pages with your impressions and capture as much as possible. Try to get at least five sketchbook spreads in a day, but see if you can do ten. It's possible! If you can keep up this pace it will prevent you from overworking things.

Stretch Goal: Go Big!

After a few expeditions with a sketchbook, consider bringing larger drawing paper out with you. You can do a more complex drawings, get in a complete street scene instead of a vignette, even begin to sketch panoramas (180 or even 360 degrees of view).

I like to carry a 16" × 20" (41cm × 51cm) drawing board. I've even gone as far as 18" × 24" (46cm × 61cm). I often bring two or three lightweight sheets of Coroplast with paper taped to both sides and sandwich everything together with large binder clips. At that size you can really get into the details. Put in all the people and cars, street lights, signage, everything that's going on. It's not necessary to go that big immediately, but you could gradually work up to there if you find it liberating.

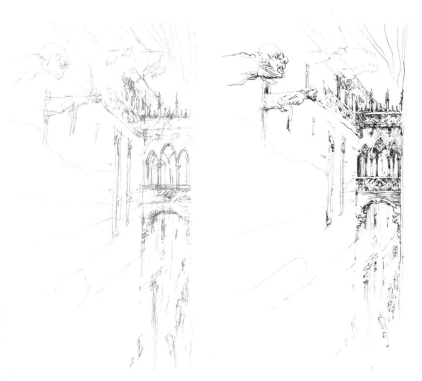

Be Picky, But Not Too Picky
Be selective. Don't sketch things simply to fill pages. But on the other hand, don't pass up something of interest hoping for something amazing. A drawing lends even a casual subject significance simply because you took the time to record it. Don't pass up a perfectly good view thinking you have to hold out for a postcard moment. Figure out what interests you. Don't look for tourist shots.

Visit artistsnetwork.com/theurbansketcher to access bonus lessons.

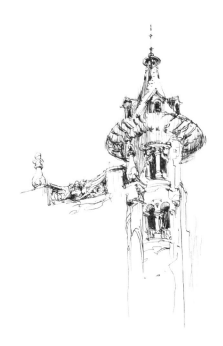

The Inquiring Mind

When you're new to a place, look for the things that are unique. New architectural styles, cultural objects you don't recognize, or possibly people's way of dressing or body types if they're different than back home.

A sketcher learns from each drawing. I'd never seen these types of towers, but I quickly learned they were common in central Barcelona.

Now I've understood how they're built, studied the radial construction of the rafters, the steep slope of the minaret. When I see them again, I know what to draw. Even if they're far away, or behind some trees, they've become part of my understanding of the city.

Stretch Goal: Train for a Sketching Marathon

Drawing takes focus, mental energy. It's common for sketchers to only work for an hour or two on location before running out of steam. After all, the easy in, easy out nature of sketching is part of its appeal (and sustainabilty).

But, what if one day you find yourself in a dream location for only a short time? You'll need to make the most of it! Think about it like being in training for a marathon. A few months prior to a big trip, start to go out on regular drawing sessions, maybe once a week. (Marathon runners find time to go every day. Treat your sketching equally seriously.) Begin to add a little more time each outing. Work your way up from a two-hour outing to an entire day on location. (Take breaks to eat and stay hydrated. Consider bringing a folding stool. Don't be too hard on yourself!) Can you gradually grow your energy reserves till you can draw from 7 a.m. to 10 p.m.? Or, if you're the type to stay out late, can you draw noon until 3 a.m.? Close down the bar with your sketching marathon!

You might find that the opportunity for a long, uninterrupted session of drawing unlocks a new kind of work. You'll have the chance to do pieces you couldn't have considered in previous twenty-minute or hour-long projects.

Exercise 7

Mark Making & Tonal Range: Values in Ink

In this exercise, identify the areas of lower-middle and dark values, where you might normally consider doing spot blacks, and instead, create dense values of marks that can be seen as tone. Try to create dark eye magnets with texture instead of solid black.

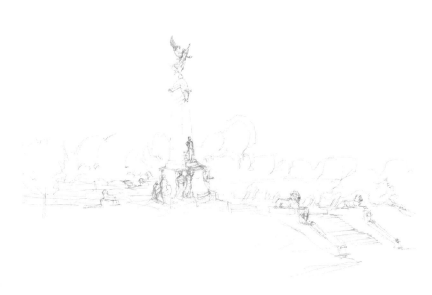

Create Unified Darks and Tonal Gradations

Try developing an accumulation of interesting, organic marks to create unified dark areas and tonal graduations. Use flicks, dots and dashes with the pen. Strive to keep pen marks rhythmic and gestural. After a while, you might start to see your unique handwriting come to the fore. This might end up being a more time intensive than is typical of three pass sketching, so choose a subject of sufficient personal interest that you'll enjoy spending quality time on. You might also consider working a bit larger than normal.

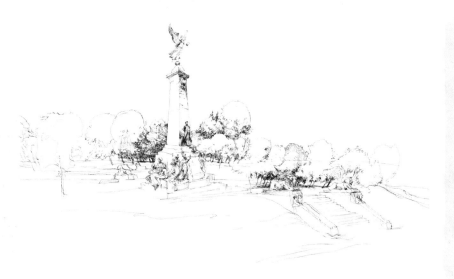

Stretch Goal: Totally Tonal

Consider trying this without line at all. You might to draw an absolutely minimal scribble (just a few minutes) and go right into developing masses of varying pen marks. Or don't even scribble at all. Go straight into values. Does the sketch hold up with only the tonal shapes? If not, can you pull it together with a minimum of lines? Try only allowing yourself five to seven linear marks for touch-up.

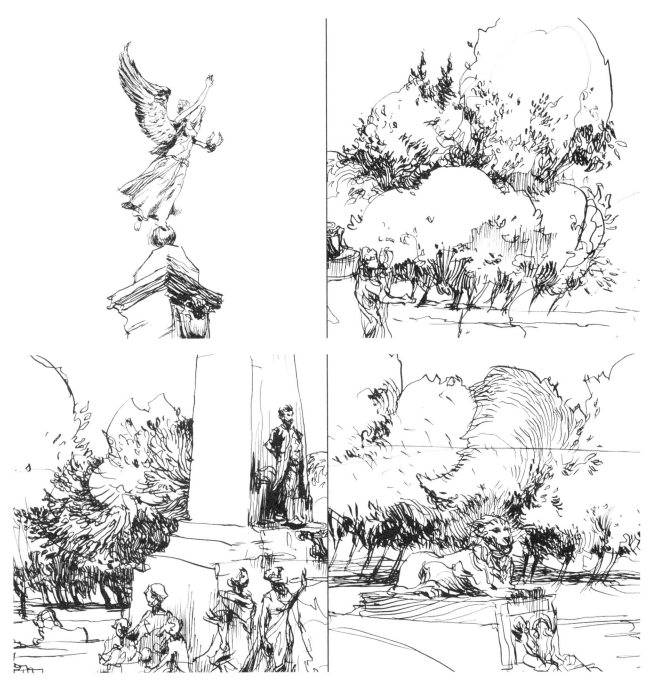

Making Your Mark

Everyone who sticks with pen and ink eventually develops their own mark making language: ways to utilize pen strokes to make the illusion of form and texture. I enjoy using a combination of vertical hatch marks in contrast with some spreading fan-like passages of knitted marks and squiggly open shapes. These marks act like brushstrokes in an impressionist painting.

Some might call this crosshatching, but I don't like to make the right-angled patterns that crosshatching suggests.

That kind of mark-making looks dirty to me. I prefer an open mark with directional flow over a surface as compared to the self-contradictory density of crossed marks.

Some people are able to make very successful drawings with calm, perfectly parallel lines, even using a straight edge. The main thing is to seek out what works for you, what sort of mark-making is most natural.

Exercise 8

Straight to Ink!

At some point you may find yourself wanting to work unusually quickly. Perhaps the weather is about to turn for the worse, or possibly you're in a dramatic situation with events unfolding in front of you. Or maybe you just want a challenge, to add a jolt of excitement to your drawing—less of a meditation, more of a flurry of action.

Go ahead and try some sketches without any pencil sketching. Work directly in ink, doing calligraphic line and spot black all in one pass. You won't have the flexibility to go back on things, so don't try to be a perfectionist. Just push ahead. There are no mistakes. If something comes out odd, just draw right on top of what went before.

I recommend dipping pens and a real brush for spot blacks in this exercise. Using the tools that have the most organic, responsive marks will give you the fullest range of options. Don't worry if these tools are hard to control. This is an exercise in controlled chaos already. Mistakes, drops, ink splatters—they just add to the excitement!

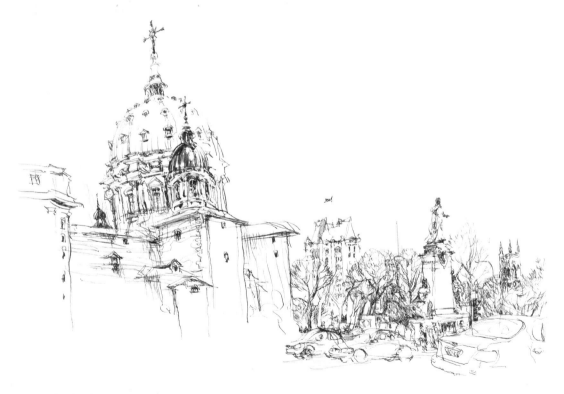

Vitality, Not Perfectionism

Whatever these drawings might lack in perspective or proportion, they will make up for in vitality. While the pencil scribble followed by calligraphic ink line is the best balance of accuracy and expression, if you want to be sketching action as it happens and seeking the most direct, most personal response, you'll probably have to go straight in with your pens. There's no faster more committed way to get a drawing done.

Drawing People in Motion

Now that you've got a grasp on the foundations of sketching in ink, let's move on to one of the most challenging aspects of urban sketching—drawing people in motion. In some ways, this should not be any more of a challenge than drawing any other subject—if you apply basic principles and draw from outside in, then you can draw anything you can see.

But of course, a person in motion never has a single shape. Their silhouette is ever-changing. So in a sense, drawing anyone spontaneously (someone unposed and unaware of your presence) is drawing from memory. You'll also be unable to rely on sight measuring to confirm your instincts. That makes things just a little more challenging, but also more exciting.

In general, there are three kinds of candid people-drawing situations the urban sketcher might encounter. In order of increasing difficulty they are:

- **People sitting still.** We can call these "captive subjects." Often they are concentrating on something like reading or working.

- **People doing repetitive motion.** This would involve sports, performance, labor, etc

- **People en passant.** This is what I call people in passing, those who are moving past your field of view without stopping.

The difference between these types of people in action is simply how much time you'll have to spend on the scribble before the pose is gone. Whether or not you have the time to refine on location or if you have to use your visual memory later. With a little practice you'll be able to sketch any active subject. From ordinary citizens going about their lives, to less ordinary subjects like performers, athletes and eventually events as they happen. Urban sketchers have drawn during earthquakes, terrorist attacks and political protests. As I write this book, we are seeing some of the first sketches coming out of the 2014 protests in Kiev, Ukraine.

Even if you are not sketching on the front lines of battle, there are always things in our lives that only happen once. Weddings, graduations, sporting events or performances. The dedicated urban sketcher may want to record these milestones with a sketchbook, rather than a camera.

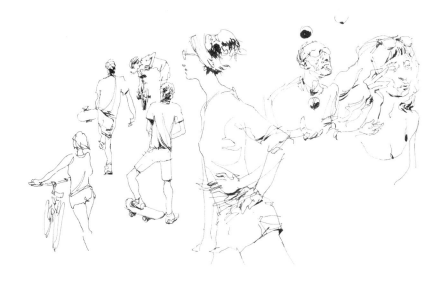

Finding Subjects

These sketches were done in on a lazy afternoon in the park. You could also find subjects in a cafe or bookstore. Sometimes it's just a matter of hitting the bricks and seeing what's out there. Walk around the downtown area of any city and you'll eventually come across something unusual. A bar or pub will work as well, (though you may have a few too many drunken art critics). You might get results from a library, especially around exam time when lots of students have to sit reading for hours. Lectures or public meetings will get you a very captive subject—the presenter. Or if you can sit backstage, even better— you have the audience as a giant captive subject.

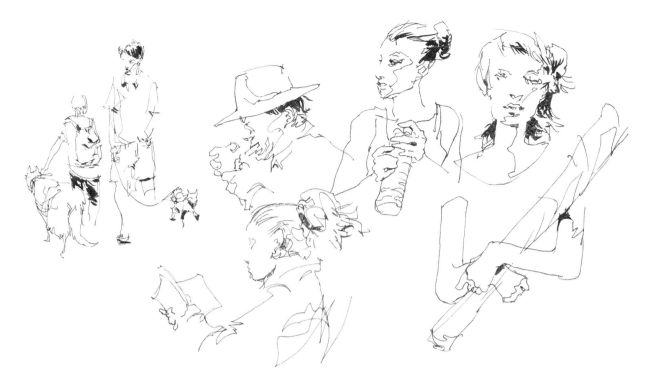

Don't Let the Pressure Get to You

Every sketch you make on the street builds up the memory banks. You're gaining experience to make the next one a little bit better. Certainly we feel pressured by the transience of live events. Thinking you only have one shot to draw something before it's gone forever can cause anxiety. If you are receptive to the idea that things are fleeting, that you're going to rely on your instinctive scribbling and your visual memory, you can switch off the natural fear that something is impossible to draw.

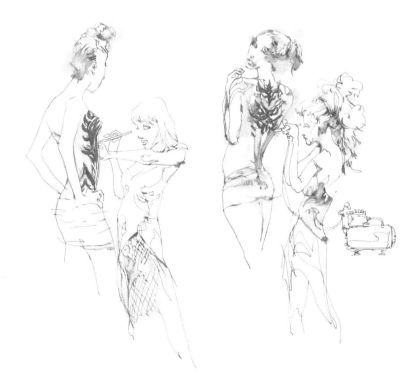

Look for Fun Subjects

Here's a few sketches from a body-painting exhibition. For me, this is a silly example of a greater truth: You can be any kind of artist you want to be. Don't sketch life passively—get out and put yourself in front of something new. If you're having fun on this journey, it won't be hard work, you'll just be living life with a pen in hand.

Demonstration

Sketch a "Captive" Subject

This fellow was part of a squad of historic re-enactors at a street fair put on by the Pointe-à-Callière Museum. The event recreated an 18th century market in the Old Port district of Montreal. He was the perfect subject for this type of sketching, as his job was to stand in one spot for ten minutes having his photo taken, then stroll to a new location and repeat.

Materials

0.7mm mechanical pencil

drawing paper

fountain pen and dipping nibs

india ink

kneaded eraser

small round sable brush

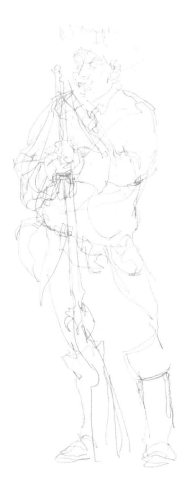

1 SKETCH THE SCRIBBLE

The trick is to try to get the whole impression in one rapid stroke. Sweep through the entire figure without getting bogged down in the details. This puts you in the best possible position to finish from memory if you do lose your subject (sometimes only moments later). It is best to leave out minor information while you concentrate on the structure. Draw the egg of the head, but not the facial features. Scribble the gesture of the pose, the weight, the direction of limbs, but save the specific description for later. Clothing, accessories, even hands, can be completed based on your scribble, from memory or further observation. Given enough time, you can add detail to your gesture. Include key information such as the musket and the big shapes in his costume. Get as much as you can before the subject moves on.

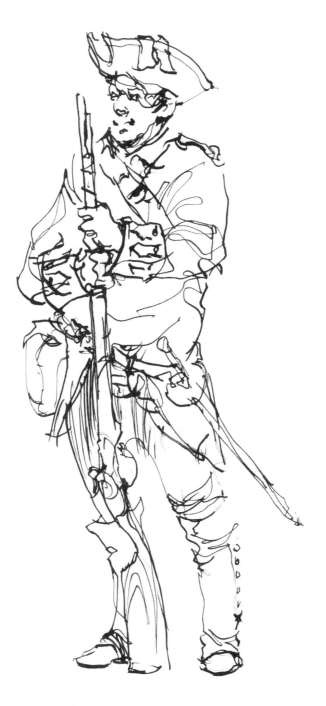

2 DRAW THE CALLIGRAPHIC LINE

Now that you have a solid under drawing in pencil, when you begin with ink, you can proceed to subdivide shapes.

Recall when you were sketching architecture, using the scribble as a guide, adding windows and doors? Now you can add belt buckles, sketch the sword and bag, put the buttons and trim on his cuffs and boots. Because you don't have to worry about drawing a figure, you can concentrate on all those descriptive interior details.

Consider Life-Drawing Classes

While it's not necessary to have a formal art education to be a successful urban sketcher, it doesn't hurt to take some academic life drawing classes. Knowledge of human anatomy can help you interpret your scribbles. You have to trust your eye to capture instantaneously, but later on it helps to know the structure beneath what you were looking at. Everything you need to know can be learned just by sketching the street. But working from the model in a formal setting has been a great asset for me and could be for you as well.

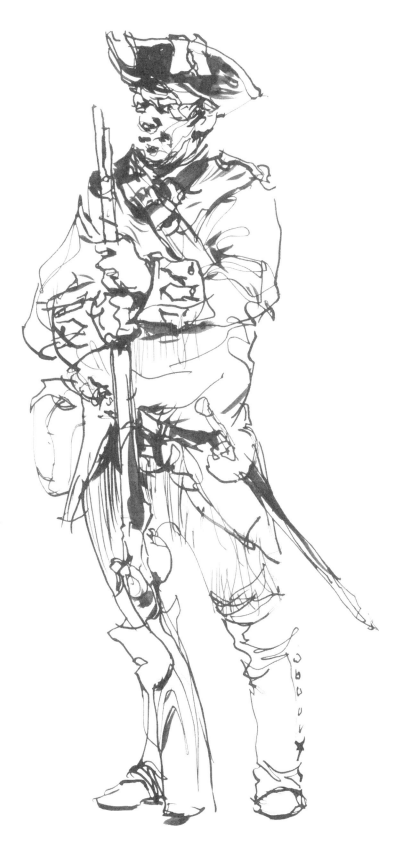

3 FINISH WITH SPOT BLACKS

When you get to the spot blacks, remember to look for contact shadows. The darks below the chin, inside the elbow and in the cuffs, below the closed fists. These small dark shapes make things look solid, give them weight.

The largest dark shape is saved for his hat. This ensures your eye goes towards his face. Remember—more visual weight in the important areas.

Demonstration

More Captive Subjects

It is best to be subtle when drawing strangers. Find a spot well outside your subject's personal space. Twenty to thirty feet away is usually a good distance, because you're still close enough to see details like facial features, but far enough that you aren't invading their space.

Try not to fidget around too much or draw attention by constantly looking back and forth between your subject and your paper. Raise your page a bit, so you won't have to tilt your head to see the subject and the drawing simultaneously. If they do notice you, don't act like you've been caught doing something bad. Just smile and show them that you're drawing. This offers them the non-verbal option to frown or wave you off. (Often, I'll show them the drawing when I'm finished. People always find it interesting and nobody has been offended yet.)

The most commonly available "captive" subjects are people sitting in cafes and commuters on the train. The advantage is that you don't have to rush the scribble, however it's easy to end up with a whole sketchbook of people having coffee and working on their laptops. Public spaces like parks and public events like expos and conventions can offer a great alternative for finding better subject matter in a variety of activities and poses. I captured this drawing of a tattoo artist at work on her client at the Montreal Tattoo Expo.

Materials

0.7mm mechanical pencil

drawing paper

fountain pen and dipping nibs

india ink

kneaded eraser

small round sable brush

1 SKETCH IN BASIC SHAPES

Make the first pass with loose looping strokes. Don't even lift the tip of the pencil, just draw through, right across forms. Draw the body behind the limbs. Join the mass of the body and scribble the angles of the limbs under the clothing, searching for the forms. Don't worry about the quality of the lines right now, as you will end up erasing most of them.

Try to get the egg shape of the heads, along with some indication of jawline. Don't go for a perfect egg shape though; these are really cartoon skulls a this point. Just try to get the dome of the head plus the angle of the jaw. This is essential because that slight bit of jaw anatomy tells the direction the person is looking, and viewers will follow the character's glance in the picture. With only the jawline, you can see the tilt of the head and angle of the eye. This is important for storytelling.

Visit artistsnetwork.com/theurbansketcher to access bonus lessons.

2 BLOCK IN THE HANDS AND ADD LIGHT DETAILS

Progressively detail the figures. Work from the outside in, adding description from the general to the specific. Begin adding details to facial features and clothing but don't finish them at this point. (Note that the bridge of the nose was not actually drawn, but implied by the opposing eye socket.)

Scribble the general shape of the hands but do not fully sketch them. Just get the mass of the "mitten." (We will focus on fingers later.) For now the position and size of the hand is enough.

Do as little as possible in each respective phase, because each pass builds on what you did before. You only need enough to take you forward to the next stage.

You also want your ink drawing to be fresh and exciting, as it's a whole new drawing on top of the scribble. If you drew every line exactly as you wanted it now, you wouldn't remain engaged in the inking. It would just become a chore.

3 ADJUST THE COMPOSITION AS NEEDED

If you were in a hurry, you could switch to ink at this point. However, since drawing "captive" subjects affords you the luxury of more time, you can take another pass at it.

You have a perfectly nice sketch at this point, but have you really scribbled the story to your satisfaction? If the answer is no, now is the time to make whatever adjustments to your composition you feel are necessary.

(When I saw the tattoo artist lean in closer, I erased the first head and re-drew this stretched-neck posture. It was a much better pose because it captured the intense focus on her work in progress.)

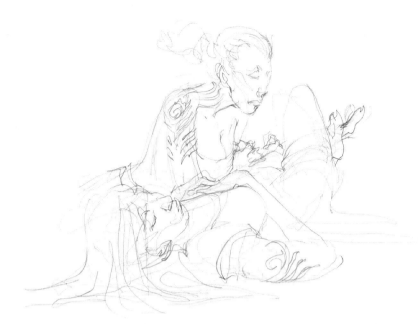

4 INDICATE EMBELLISHMENTS

As you reach the end of the pencil-sketch stage, indicate embellishments and other details, in this case: the ink designs on their arms and the folds of the clothing.

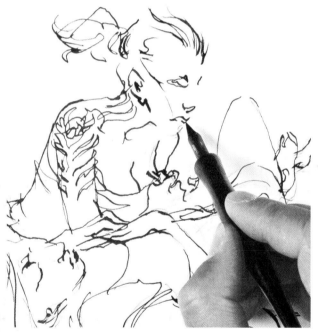
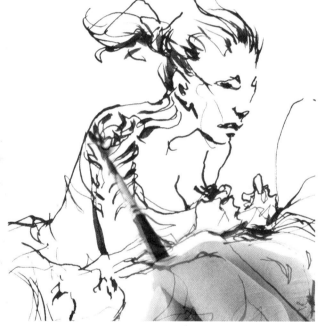

5 INK IT

Ink in the final calligraphic line and the spot blacks. Avoid making completely sealed outlines around the forms—this will make your drawing look stiff and cartoony. Instead, keep a loose freedom to your pen and try to leave the shapes "open."

Continue adding details. Use small open gaps to suggest light, like on the bridge of the nose. Use the spot blacks draw the viewer's eye in, telling us which of these two people is the main character in the story.

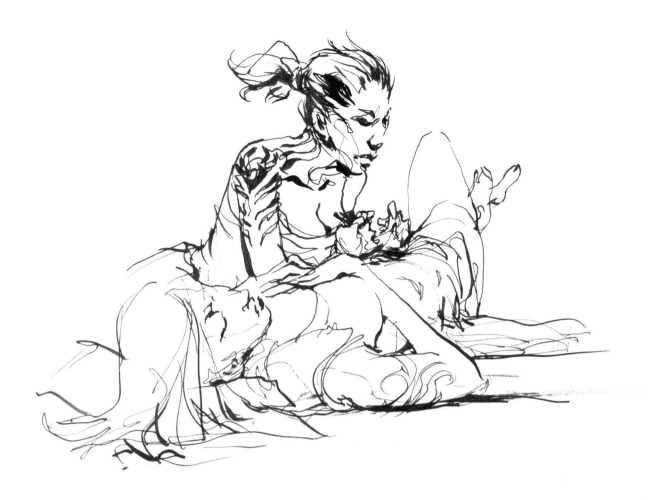

6 ADD FINAL TOUCHES TO FINISH

After finishing the spot blacks, add a few looping shapes with a ballpoint pen to imply small shadows. In theory the line phase is over, but you will want to go back and add a touch here and there. In this case, that would be to detail the main character's face. Add more to the story by drawing little frown wrinkles and small shadows under her nose, lip and chin. Add a tiny scribble at the wrist to indicate her gloves. You might think that nobody will notice these tweaks, but if nothing else, put them in for yourself.

A Note on Pens & Inking

Never think of ink work as tracing. It is a much more sophisticated drawing than the scribble. However, that doesn't mean that it's not great fun drawing with ballpoint pens. They zip along the surface, easily changing directions and making smooth continuous lines. (They also work very well for smaller shapes.)

Demonstration

Sketch Repetitive Motion

Once you're comfortable sketching those relatively reliable captive subjects, challenge yourself to the next level of difficulty—sketching people who are actively engaged in a task, doing things that have them in a constant state of motion. Most work or play involves cycles of repeating activity. Let's call these characteristic cyclical repeating movements *key frames.*

Musicians are my favorite example of this kind of this. The more emotional or aggressive the music, the more they use their entire body. Violinists for instance, lean into the bow, twisting the torso. Rock guitarists are notorious for prancing around on stage. They repeat postures based on the rhythms of the music. When a refrain calls for the same notes, they often take the same body positions. You can almost predict when poses will happen just by listening. (Plus, you know that as long as the song lasts, they won't be walking away, which is useful for timing your sketch.)

You might find this more difficult than sketching captive subjects, but don't be discouraged. It gets to be a lot of fun after some practice.

Materials

0.7mm mechanical pencil

drawing paper

fountain pen and dipping nibs

India ink

kneaded eraser

small round sable brush

Tip!

I have a trick to share about repeating motion: Do more than one three-pass sketch at time.

Working in pencil, scribble the first pose that grabs your attention. As soon as that pose vanishes, just shift over on the page and start the next interesting posture. Space them out nicely over your paper, or sketch each on its own page.

Wait for the cycles to repeat and follow along, switching poses as they appear. Add information every time they repeat. Never stop drawing, use the down time on one pose to advance another. The ones that get finished over the session will be the important ones. It means those are the poses that repeated the most often. (Or at least similar poses appeared). The ones you only scribble once probably weren't all that descriptive anyway, as they didn't reoccur.

This approach doesn't always work, but you'll quickly learn when you're in an appropriate situation to try it.

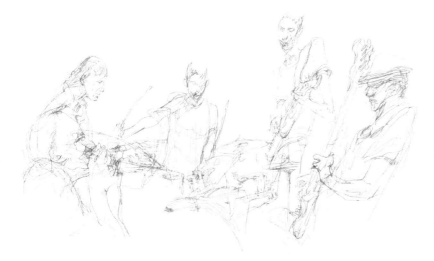

Pencil Scribble

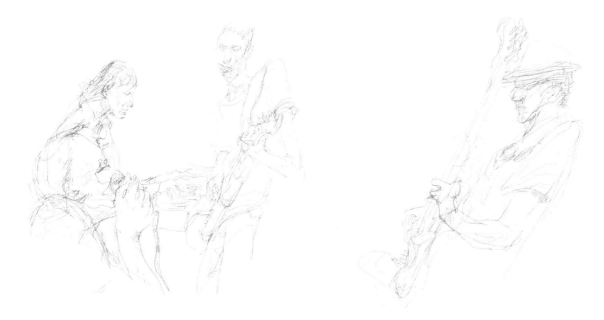

1 SKETCH THE SCRIBBLE

When sketching repetitive motion, think of the line as more aggressive, the gestures more exaggerated. It's okay to be less correct to the precise movement and more true to the "feeling" of the movement. In this case, it quickly became clear the keyboardist was the easiest element (essentially a captive subject) but the guitarists were moving all over, bobbing and weaving, stepping up to the mike in alternating turns. I ended up drawing each one leaning back when the other was singing. Every so often the harmonica player would stand up and do a wicked solo, but he was thrashing around, sawing on the harmonica like a man having a coughing fit, so, I didn't manage to pull one those off.

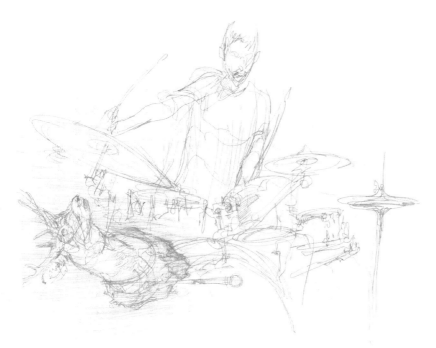

Time Check
I ended up putting the drummer in last. (The drummer never gets any respect!) All together, sketching the scribble for all five figures and instruments probably didn't take more than 20 minutes (if you don't consider false starts and unused poses.)

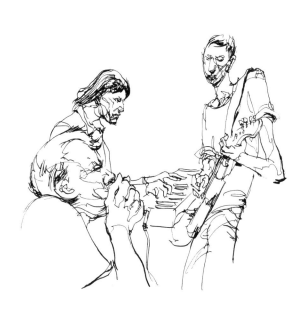

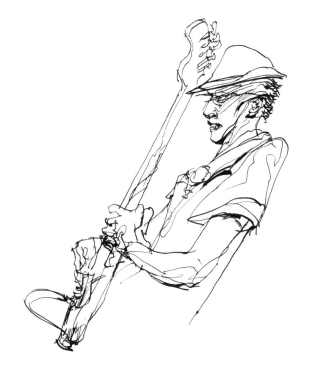

2 DRAW THE CALLIGRAPHIC LINE IN INK

It is of course, ideal to be able to finish all three passes for your sketch on location. However, in a lot of cases, your subject might be gone by this point. Although many urban-sketching purists feel that the idea of improving the work later rings false, the reality is that you will often have no option but to finish up the drawing from memory. Personally, I'm okay with it. If the subject sticks around, then great, but if they leave, what can you do? (Besides, it will help you learn to draw faster!)

If you do lose your target in the middle of a three pass drawing, you can still be okay. The gesture contains the posture and proportions. It's just a matter of carrying on, trying to complete the sketch before the details fade in your mind's eye. Make every effort that your sketches don't lose freshness or authenticity. Try to finish them as soon as possible. If not right on the spot, then at least later that same night.

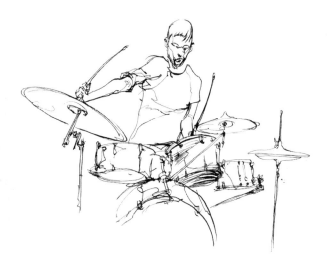

Straight to Ink

If you are feeling confident, and would like to experiment, this sort of subject would be worth trying straight into ink. Merge the scribble and the drawing into one pass. Just begin with a reasonably fine line pen, and work from a looser gesture, seeking the pose and proceeding toward denser details right on top of your initial ink line. Possibly moving up to bolder pen as the image resolves. You might find this makes you speedy enough to scribble things you'd otherwise miss, but at first it's going to be messy. It helps to have both a good knowledge of anatomy and an open mind, to be happy with more spontaneous and less accurate results.

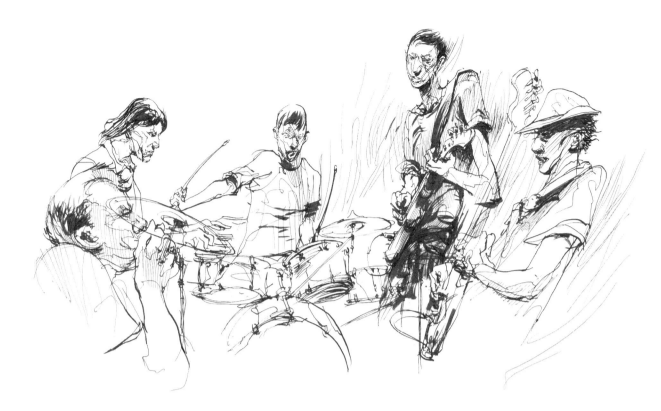

3 FINISH WITH SPOT BLACKS

Finish off with a few spot blacks and some ballpoint-pen linework on top. You want to turn up the volume. Get linework that's suitable for the high energy of the atmosphere.

Digital Collage

The bar band example is also a demonstration of another favorite trick: designing a collage on the fly. That is, drawing a set of overlapping sketches on location, that I plan to collage into a single drawing before painting. When sketching the band, I knew I was going to be finishing back in the studio and could collage all the individual portraits back into their positions on stage.

Sometimes when drawing a scenic view, I'll just start at an interesting spot and work outwards. Whenever I hit the edge of the paper, I take another sheet and extend the drawing. I hold the second sheet slightly overlapping the first and draw right over the seam. I can keep adding pages and make as large a drawing as I want, even if I'm only carrying letter-sized paper.

In the old days an artist might physically cut up and re-assemble the drawings and painstakingly transfer them to a larger sheet. Now it can be done digitally. I use Photoshop, but there are alternatives, some of them available to download for free. Most photo editing software, and even some iPad apps, make digital collage quite easy. I admit this might be stretching the definition of urban sketching. This is the only thing I'll put into this book that you could not do on location. If you're a purist and you want to be able to say your drawing was 100% done in the moment, this approach might not be for you. My feeling on it is, I know I can do it both ways, it's just a matter of convenience. I'm enjoying sketching from life, and that's all that matters.

Exercise 9

En Passant: The Long View

· ·

The final level of sketching people in motion is capturing those not conveniently doing something for your amusement, but only seen for a few moments as they flow through your scene. I call it *en passant*, the chess term for *capturing in passing*. In the normal case of a person walking towards you, even in the best situation where you have a unobstructed view, you have only the time between spotting your approaching subject and about 20 or 30 feet before they pass you by. It's very rare that you have a longer sight line than this. People in the extreme distance are just too small and are frequently blocked by the crowd in front.

Say you have a 10-15 second window to sketch. That is not a lot of time, but there is a strategy for this situation. The most basic thing you can do is to widen your window of opportunity. Try and find a position that gives you the longest possible view of the most people. You want to be a small island in a river of people, with a long straight (preferably uphill or downhill) view. A steep angle allows for seeing over people's heads, so they don't obscure each other as much. The further you can see, and the more populated the street, the more fuel you will have for your fire. You want the best possible view for the longest possible time. (Even if that's not very long.)

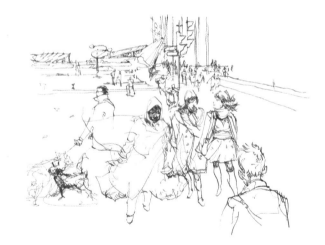

Choosing Your Vantage Point

The idea behind composite figures is to artificially lengthen the window of sketching opportunity. Don't restrict yourself to one exposure. Instead of trying to draw an entire person in that 15 second window, create a composite figure, combining multiple passersby as if they were key frames of a single character in motion. In a given crowd of people there are always "types." People dress according to fashion trends, their jobs and economic standing, and the local weather.

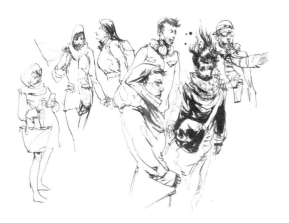

Composite Subjects

Choose a character type such as "Lady with Colorful Scarf." If you've chosen well, you'll get a matching character type in short order. There is actually an endless supply of fashionable women in long scarves on a fall day in Montreal. You'll see how easy it is to add a little detail from each of them. Just as with the key frames of repeating motions, you can combine these passing types into a single drawing. Try and spot your character types as far back as possible and keep your eye on them. Don't get distracted by anyone else until they get so close they're about to stride out of your working zone.

If you can gather one detail from each person (the shape of a hairstyle, a pair of glasses, the clasps on a bag) fairly quickly, you'll have an entire composite figure. The gesture is the framework you are looking to fill in. Add appropriate details on top of the gesture so it hangs together as a convincing person. The character types that are more common are by definition best descriptions the time and place you are in. Whatever you are seeing a lot of is what will get drawn.

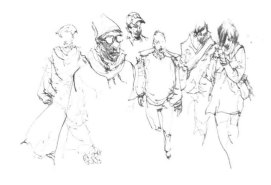

Multi-Task and Try Going Straight to Ink

Try to get four or five character types going at once and you can do the multitasking trick while you wait for clones to appear. This is an excellent time to try skipping pencil and going straight to ink. Speed is of the essence here, so this is a good time to save a step. En passant is a great way to become more comfortable sketching without the safety net of pencil. You end up drawing so many people so quickly this way, it's possible to get a tremendous amount of training in a single day.

A serious student might set aside a small sketchbook and try to fill the entire book with direct-to-ink en passant sketches. Care to devour your way through an entire book in a week? Or a month? If you can do it without editing yourself or concerning yourself with quality, but just simply devoting yourself to the process, you will see tremendous results.

Receive bonus materials when you sign up for our free newsletter at artistsnetwork.com.

79

Exercise 10

Heads & Hands Storytelling Portraits

In this exercise, draw only the upper half of your captive subject. Sketch a head-and-shoulder portrait and show what their hands are doing. You could possibly include a key prop. What is the point of this? When you're short on time, you sometimes have to draw only the most important stuff. Capturing who the person is (the portrait) and what they are doing (their hands) is the most compact story you can tell. Plus, if you draw all the way to the feet in a typical sketchbook, you're probably making a head that's less than an inch tall. It's hard to pull off an engaging portrait at that tiny size.

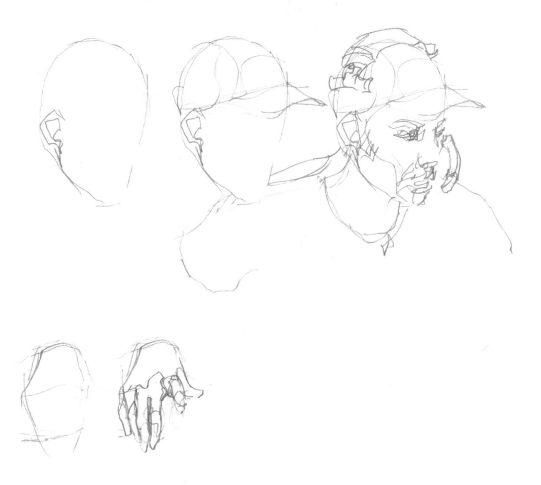

The Scribble

The best way to capture a rapid likeness is to scribble a "cartoon skull," the egg-like dome of the skull plus the jawline and ear. Observe the overall shape of the head. Is it a slender, oval, or chunky blockhead? If you indicate the angle of the jaw by drawing the loop-and-hook of the ear and the chin, that tells you everything you need to know about the placement of the features. (Tilt and rotation.)

Sketching outside in, divide the head into the biggest interior shapes. The shape of the hair, (or hat), the next largest shape, glasses, bow ties, etc. The features go in last.

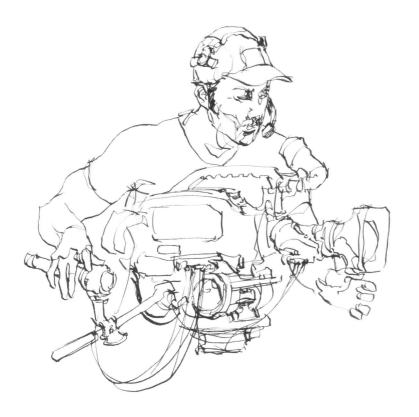

The Calligraphic Line

Try to do the scribble and calligraphic line without stopping. (The subject might leave at any time!) You'll have to rely on memory more and more as you work on moving subjects, so this is the time to practice getting it all from life. Build the visual memory and figure-drawing skills you will depend on later.

Many people have trouble with hands. They are indeed, complex shapes. Just remember to draw outside in. Scribble "the mitten" of the hand—the outside shape, and then fill in the fingers with the calligraphic line.

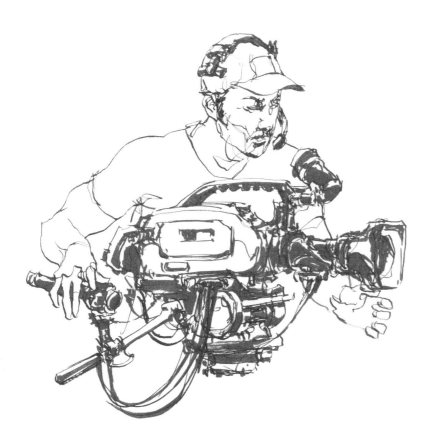

Spot Blacks

If you can include a prop along with the head and hands, even if it's just a cell phone or a coffee, it can imply an entire narrative. Just drawing a floating portrait leaves out the storytelling context.

Exercise 11

Repetitive Motion:
People At Work & Play

After you feel comfortable with captive subjects, you can move on to capturing key frames from repetitive motion. It can be tricky finding great subjects for this key-framing exercise, but anyone who is working or playing has potential, as they tend to stick around and generally do the same thing for a decent amount of time. You might try a trade show of some kind. Usually these can be attended by the public for a small fee, and you'll find demonstrations of products going on all around you.

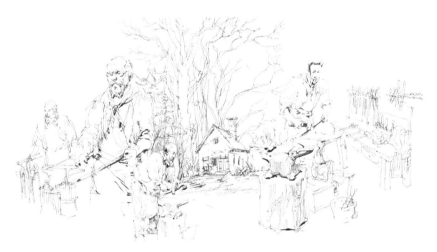

Repeating Cycles
This composite sketch of working blacksmiths at a historical park depicts artisans demonstrating traditional crafts with antique tools and techniques. The nature of their work involves going back and forth from the forge to the anvil, heating and hammering the metal—a perfect repeating cycle to draw. I made sure to include some of their tools, and even a sketch of their hundred year old stone blacksmiths shop.

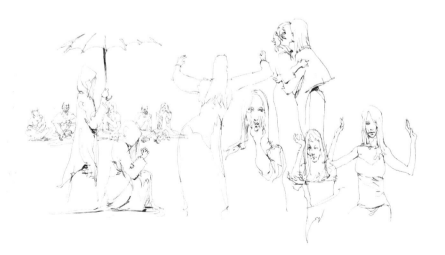

Repeating Postures
These sketches were from a modern dance performance. I used the repeating postures to improve my lightning-fast scribbles. Each cycle some of the motions repeated, eventually forming the entire story.

Composite Figures: Combine a Crowd Into One Ideal Character

For this exercise, look for an activity where there is a group of people doing the same thing. A golf course or tennis courts would be a good place to start. Also, dog walkers are all generally the same, even if their dogs vary considerably. (Nobody will notice if you switch up people with new pets!) You might try skateboarders or BMX bikers. Those guys can usually be found endlessly practicing tricks. Any sporting activity is also a possibility. If you know anyone on a local team or club, perhaps you can come down and watch a practice. Their training drills will offer groups of similar people doing similar things. People flying kites at a festival, or jumping their horses at a show… the opportunities are out there once you start looking for repetitive motion.

Stretch Goal: Character Hunting

Make a list of stereotypes you might find on location and see if you can find them in the crowds. In just a few lunch hours, you might be able to collect characters like this:

- Business types on cell phones
- Bike couriers waiting for dispatches
- Smokers outside their offices
- Daytime joggers
- Office workers eating lunch in the park

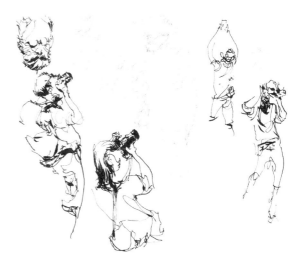

Essence of the Gesture
These sketches of tourists taking photographs in one of Montreal's historic town squares is a good example of a group of people doing a fairly repetitive task. If you observe for a while, you will see the same pose over and over. It might be a completely different person doing it, but the essence of the gesture is very similar regardless.

Moving Targets
Start your first scribble using a likely target. Ideally you'll get a complete drawing, but if they move away (count on it happening), you have your basic gesture to build on. Then it's a matter of waiting for a similar gesture from someone else. It might also be necessary to draw on the move. If you spot a likely subject and end up following them at a distance as they move, you'll be moving too so they stay in your sight and at approximately the same angle.

Exercise 13

One-Page Graphic Novel

This exercise will combine all your people-sketching skills with the intent of capturing a complete story, a one-page graphic novel that shows, pose by pose, the process of someone doing something interesting. The goal is to sketch your subject in a series of key frames that aim to describe the start, stop, and finish of a task, and perhaps call out few details of what goes on in between. Try to design your page to tell the story. The time sequence of images should ideally be in the right order, and perhaps you will plan it out so there's room for a larger sketch in the middle, with smaller ones around, or maybe just close-ups of hands using tools, or smaller gesture sketches of fast motions.

It can be tricky to arrange seeing something from start to finish. Sometimes you will arrive too late for the whole story, sometimes an activity is going to take all day, and you can't hang around that long. If you run into some action already in progress, don't worry. Jump in and get what you can. Even a partial story can say a lot when combined with some journal writing. Perhaps someday, you'll run into something very similar, and you can piece it all together.

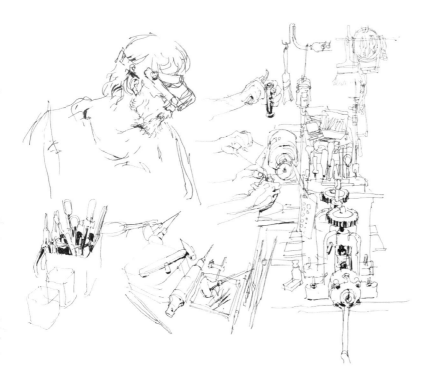

Don't Forget the Props
These sketches are of Montreal goldsmith Marin Marino, at work in his jeweler's studio. I was especially interested in sketching the tools and associated paraphernalia around him. What specialized equipment do your subjects need to do their work or play their sport? What poses and props are part of the process? These things can surround the figures and help tell the story.

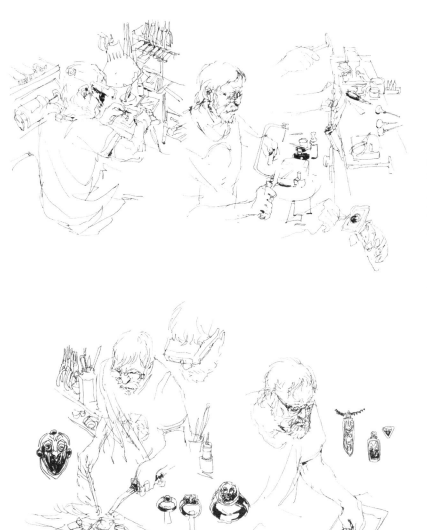

Opportunity Is Everywhere

It helps to be always on the lookout for opportunities. Nearly everyone you meet works somewhere interesting or has some sort of exciting hobby. If you keep asking friends and associates, you may be surprised what you find. It's kind of a game, worming your way into places people don't usually get to sketch.

Evaluate

As you do your own one-page graphic novel, look back and see if you've captured the essence. Does the sequence work as a story? Do you have props, costume or interesting gestures that narrate events? Do you have a beginning, middle and end to the tale?

Stretch Goal: Do a Visual Essay

If you find you love this kind of sketching-as-documentary, you might enjoy making it into a larger project. In January 2013 I did a month-long experiment in which I sketched the rehearsals for a play in production at Montreal's Centaur Theatre. I visited every other day and drew the actors as they repeated their scenes. You can read about it on my blog archives at citizensketcher.wordpress.com/innocence-lost-/production-diary.

Many towns have a community theater that might be open to a project like this. Other urban sketchers have done this at their civic ballet. Your storyboard of a single task could grow into an entire sketchbook on a favorite topic. If you can make this sort of longer term commitment, you'll see some great results. Your drawing will dramatically improve if you can keep at it on a regular basis. And if you're drawing the same people week after week, you'll find your portraits becoming more and more sophisticated.

This is a tricky thing to make happen, but the benefits to a long-term project like this are tremendous. Besides all the practice I got, I had enough finished work to hold an exhibition of drawings at the theater, and I was able to take the artwork on tour, and hang it in our National Art Center in Ottawa when the show traveled there. I was part of the theater's promotional campaign for the entire season, and ended up being interviewed on local radio, and the NAC website. Overall, it was a very rewarding project, that grew naturally out of my ongoing sketching.

Exercise 14
Multitasking
· ·

Now we move on to the most challenging kind of sketch: a figure fully in motion, never standing still. Choose any subject involving rapid, non stop movement. If you can get comfortable with sketching this type of subject, you unlock the ability to sketch live events of all kinds. Being able to jump back and forth, getting a detail here, returning to a sketch over there—that's a kind of multitasking that will allow you to make an action scene out of a unscripted real-life situation.

If you give this a exercise few serious tries, you'll find yourself more and more willing to try and capture fleeting scenes in public. It's great to have the confidence that you can draw anything that comes your way.

Surface Options

You could approach this experiment with my own preferred method, using multiple drawing boards and switching between drawings. Or you could just bring a larger book and do it all on one page. You can't really work in a small sketchbook and flip pages back and forth for this type of exercise. The wet ink will stick the pages together. With plastic drawing boards, you can just lean the wet pages on the leg of your chair (or your own knee) facing in to protect the wet drawing.

Multitasking

The goal with multitasking is to be able to keep drawing continuously, using all of your available time. Never let the pencil be idle as the motion happens in front of you. Even a slightly similar pose might give you data you can use to draw a hand, or fill in an expression.

Ultimately this is just a speed training game. It's not always necessary to have to work this quickly. If you find it frustrating, take a break or come back to it another day. But if you can be in a mind set of just drawing for the enjoyment of it, of letting the line happen automatically without thinking, you might find you really enjoy the results. I know I find it exhilarating. Sketching at top speed, straining to see every motion. At the end I'm often exhausted, but I've had a great time.

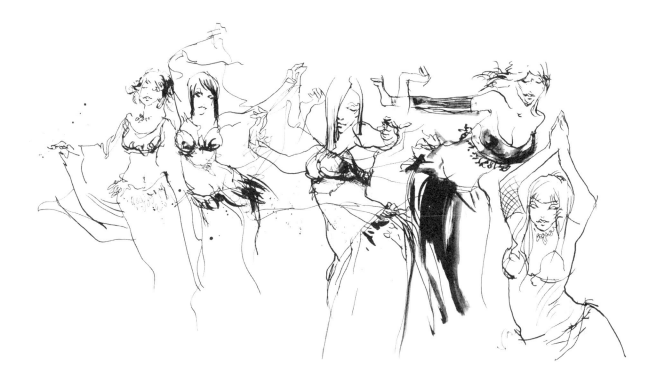

Location, Location, Location

Keep in mind that some performances don't lend themselves to sketching. The ballet, for example, is dark and the people next to you are quite close to your flying elbows. Plus everyone has paid to see the show, so it might not be polite to distract them with your scribbling. You could possibly get away with it at a rehearsal. Sometimes students can get into see pre-show dress rehearsals. Contact your local groups to inquire.

I recommend sketching at a dinner theater performance, which is more casual and not seated so closely together. You can always find belly dancers at Middle-Eastern restaurants and hookah bars. Keep an eye out for daytime events in public, also. Ethnic dance groups often do performances at street fairs. Often at these kind of things people are taking photos, kids are running around, and there's street noise in the background. I don't think a sketcher is any more intrusive to the performance than all that. Of course, you'll have to use your judgment, and hold off if it seems like you don't have the space to work, or if it's a particularly serious event.

Demonstration

Bringing the Street to Life

It's high time to bring the city back into these drawings of people. I call this exercise *Actors on Stage*. It brings everything we have done so far into a complete picture, combining the location and the activity going on inside of it into a full-fledged street scene.

Find a wide view; a city park, a public square or a major intersection. Choose something that has a steady flow of people, and ideally, an interesting architectural backdrop. Scribble the street scene in pencil. Make it a nice wide-angle view with plenty of foreground. You are preparing the stage your actors will play upon.

Materials

0.7mm mechanical pencil

drawing paper

fountain pen and dipping nibs

India ink

kneaded eraser

small round sable brush

1 CHOOSE THE SCENE

Camp out for a while and watch the people for at least 20 minutes. Start choosing the "types" that might go into your drawing. You're casting your actors. Draw figures right on top of the background, erasing the scribble where necessary. Leave the background in pencil until the composition comes together. You can go back and complete the scenery, but you might as well wait until it's covered to see what shows through.

2 CREATE COMPOSITE SUBJECTS

Combine captive subjects if you have any available, (people waiting, street vendors, security guards, whoever can't leave), with sketching people en passant. Consider making the captive subjects focal points and fill in the crowd scene with composite figures. A classic example is something like a traffic cop in the foreground. They are on duty; they can't run off on you. I'll often use cars as compositional devices. Nothing says 'street scene' like traffic. Then just fill in the crowd behind with composite figures streaming by.

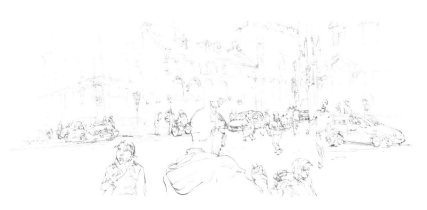

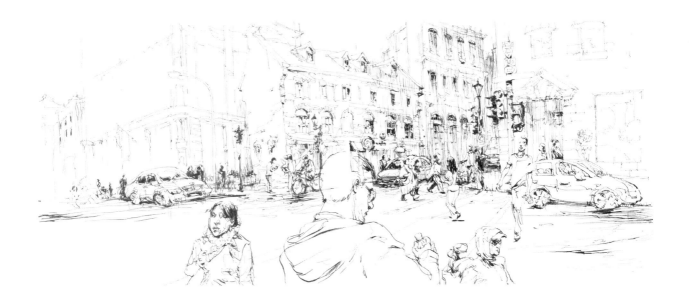

3 CONTINUE MULTITASKING AND FLESH OUT DETAILS

Remember to multi-task on figures. Put a scribble down where it makes sense compositionally and wait for the right passersby to flesh it out with details. Remember the sketching sequence: pencil scribble > calligraphic ink > spot blacks. This time you're doing it twice over, once for the background stage, and again in parallel as you sketch the actors. At the end, you'll have a bustling street scene that you might once have thought impossible to draw.

Stretch Goal: Reporting Live from the Street

There is a way to take this even further. Why not actually become a reportage artist for the day? You might attend a (peaceful) political protest, a labor dispute perhaps, or a right's march. Or in some areas the public may view ongoing trials inside the courtroom.

Perhaps doing something of real significance like this will put you in a more serious mindset. Now you have a challenge with some responsibility. Can you accurately capture real-life people and events? How does your personal feeling about a situation affect your sketches? Can you convey the emotional tone of the story you are witnessing?

As with all public sketching outings, exercise all reasonable precautions for your safety. Remain aware of your surroundings (don't be overly focused on the drawing), pack your gear wisely (don't be vulnerable to pickpockets), and if a political event gets serious, be prepared to leave at a moment's notice.

Receive bonus materials when you sign up for our free newsletter at artistsnetwork.com.

89

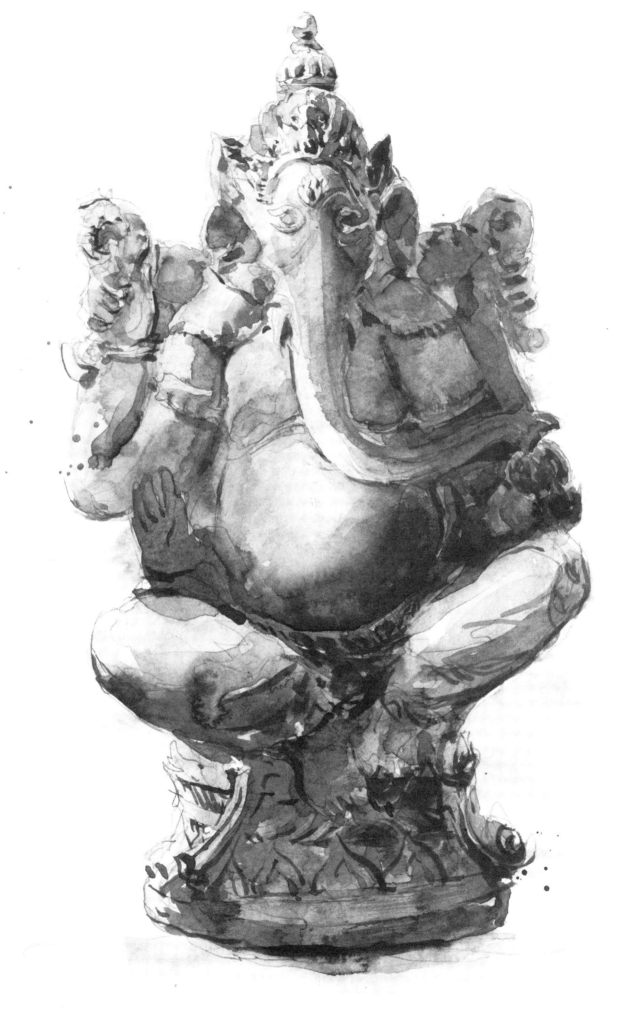

CHAPTER THREE

Watercolor: Bring Sketches to Life with Color

· ·

At last—you get to work in color! Color really does add so much to a drawing. For many artists, this is when a sketch comes alive. When you combine color with the other techniques you've been practicing, you'll be able to tell some great stories. You can convey the heat of the tropical sun, or the melancholy of a rainy day with just the tone of the sky. Colors can immediately set the season, even the time of day. The colors of foliage, or sometimes rocks and dirt can tell you where in the world you are standing. Where an ink drawing has drama and power, a painting in full color has the potential for many moods, and for more compelling, more sophisticated storytelling.

You can apply the principles from this chapter to any media—pastel, colored pencils, oils or acrylics—but for me, watercolor is the natural choice for the urban sketcher. It's quick, it's portable and perfectly suited to working over sketches.

Key Concepts in This Chapter...

- Making the water work for you: Control pigments in suspension with techniques for drawing with a brush such as growing a wash, charging in and edge pulling.

- Adding color to your sketchbook: Use a line and wash approach to painting by starting with tinted sketches. This natural step will leverage everything we've covered so far.

- Three-pass watercolors: Use the transparent nature of watercolor to your advantage. Learn to work in three passes of gradually increasing pigment strength, building on what you learned so far to create expressive watercolors with a strong sketching foundation.

Watercolor Tools

- **Watercolors.** The best solution for everyday carry is a set of miniature travel pans. You don't need to carry a separate palette or safeguard squishy tubes. These tin (or plastic) box sets can survive in the bottom of your bag indefinitely without drying out. I use Winsor and Newton artist quality pans just because like the high pigment strength and they're widely available. People I trust recommend other premium suppliers such as Kremer or Blockx. They will all mix together, so you can assemble a custom set with your favorite pigments.

 Pans tend to be more expensive than tubes due to their dense compression of pigment but even half pans (as shown) will last through weeks of steady painting. Everyone has favorite colors that get used faster, so you end up replacing only one or two at a time. After the initial big purchase it's not that bad to maintain the watercolor habit. I love the convenience of these miniature kits, and rely on them when I'm traveling light, but pans are only good for smaller works. They're perfect for sketching in a 5"× 7" (13cm × 18cm) book, even up to the 8 ½"× 11" (40cm × 28cm). Anyarger than that and you start to need a full-size palette to mix enough color.

 Ready-made kits usually have good all-purpose color selections: primary colors plus green and a few earth tones. Some people purchase cakes of pigment individually and customize their kit. You can get crafty and glue pans into any re-useable tin to make unique sizes and color combinations. (Google the popular Altoid Tin Watercolor Kit.) I've added a few extra pans to this kit (after tossing a foolish little folding brush that was too tiny for anything.)

- **Brushes.** Everything covered on brushes and ink in the previous chapter applies double for watercolor. Good sable brushes are a joy to use. They keep a sharp point for detail, yet can hold a lot of water for washes. They can even be used for textured dry brushing so you don't need to pack as many sizes.

Watercolor Setup
I have adopted a "sketcher's kung-fu grip" that allows me to hold both the book and the ink bottle in on one hand, so I'm free to draw while standing. I keep a scrap of tissue tucked around the bottle to blot the pen nib.

Visit artistsnetwork.com/theurbansketcher to access bonus lessons.

With synthetic brushes, you'll need as small as a no. 0 to get fine lines, and as large as a no. 12 (and up) for larger areas. If you have space for only one brush, bring a no. 10 self-enclosing, threaded Da Vinci travel brush. This is a very expensive brush, but if it can take the place of six synthetics in your mini-kit, and do a better job, then it's worth it.

- **Sketchbook/Paper.** You can find bound books of textured watercolor paper or smooth multi-purpose stock in 100-lb. (210gsm) or higher from companies like Moleskine, Hand Book and Stillman and Birn. You may run into books with wire coil bindings. In my experience the paper may be wonderful, but the coil bindings do not survive being carried in your bag. The wires get bent and the cover falls off or the pages start catching when turned.

I use 140-lb. (300gsm) cold-pressed 100% cotton rag watercolor paper in sheets. (Arches, Fabriano, Saunders, Waterford—try a few brands, see which you like best). It's cheaper and more flexible to buy full sheets and cut down to whatever size you want. This also allows for odd formats like long and thin panoramas. I also use machine-made watercolor papers such as Canson Montval or Strathmore 300 series. These come in various sized pads and blocks. This kind of sized paper is great for capturing fine detail and is very receptive to charging and lifting pigment.

- **Water container.** You'll need a larger leak-proof water container, something with a wide enough mouth to reach inside. I use a 500ml/16oz Nalgene that's a good compromise between weight and having enough liquid. The water gets dirty while painting, so I take the opportunity to refill whenever possible, at public fountains, rest room breaks, and so on.

- **Paper towels.** Always have these handy for blotting out corrections as you work. You have a brief window to undo a mistaken brushstroke before it soaks in. Just blot and lift it away. (I always have a square of paper towel in my off-hand while painting.

Painting Wet-On-Dry

A wet shape you've just painted can be thought of as alive. As long as it remains damp it is active, wanting to move. Unless your disturb it, it will sit in a puddle, waiting for an opportunity to flow. On a fresh white sheet, it is surrounded by an area of dry paper that is dead, inert. Watercolor pigment will never cross the wet/dry (alive/dead) edge. The moment it reaches the dry paper, it abruptly stops moving, piling up along the dry border, forming a sharp edge. If you look closely at the edge of a watercolor puddle, you'll see an accumulation of pigment (microscopically) piled up on the wet/dry edge like a high tide line.

As long your living wash has wetness to flow into, it will keep moving. If you make two puddles' edges touch, they will merge together, one color flowing into the other. If the paper is even a little damp, it's still alive. Pigment will float when wet and creep when damp. It's still moving, just very slowly.

Thus, if your paper is wet in a random area you accidently touched, or in an area you thought had dried but is still damp, pigment may creep in those directions. Even if it looks dry, if the paper feels cool, to the touch, it still has moisture in the fibers. This is why wet-on-wet painters who pre-soak their entire sheet can get soft focus images. Everything gradually blooms. This can be a beautiful effect, but as a sketcher who draws a lot of detail, I don't usually go that route. It's a matter of taste, but most urban-sketching subjects, (cityscapes, architecture) call for a fair number of sharp edges and a lot of small detail that is impossible to get on soft-focus soaked paper.

So, I prefer to work wet-on-dry. You can keep control of where exactly the wet/dry edge is and when you allow two shapes touch. You can work logically, separating one shape from the next. Your colors will do beautiful organic things for you in the live area and stop where you want them to at the dry edge. In this chapter, we'll use this concept in a number of different ways.

Demonstration

Grow a Wash Technique

The basic maneuver of drawing in watercolor is something I call *growing a wash*. Join brushstrokes of wet color to fill the shape you're describing. It's similar to the first shadow-shape exercise you did in pencil, only much faster and with color. The goal is to use the wet/dry edge to properly draw the outside of the silhouette. The outside should be sharp, while the strokes inside fuse into soft tones.

Materials

140-lb. (300gsm) cold-pressed watercolor paper

round brushes of various sizes

watercolor pigments

paper towels

1 LAY IN THE BASIC SHAPES

Work one logical shape, from the top down and the center out. Go one shape at a time without stopping. Each stroke you make inside a shape touches the one before so that the live pigment melts together.

2 CONTINUE BUILDING UP THE SHAPES

Don't leave any gaps. Let each new stroke of color add to the shape, expanding it out to fill the area you're working. Try to make a series of welded, fused strokes. Continue without pause until you've drawn the shape you're describing. If you stop before you finish a shape, you'll get an unwanted dry edge inside the form instead of on the edge where you want it.

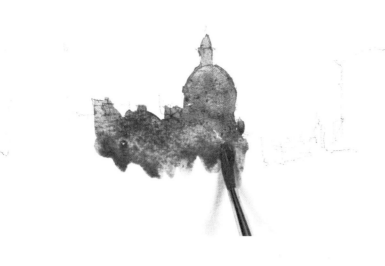

3 VARY THE COLORS

As you progress across or down a shape, vary the color of your paint mix. Every time you go back to load your brush, make a small color adjustment to your reservoir of color. Add in a bit of complementary color, or a stronger dose of pigment. Keep your mixes interesting and try to capture small variations in what you see. Always mix at least two or three pigments. (I use a lot of warm and cool combinations, such as Burnt Sienna and Ultramarine Blue, or Yellow Ochre and Cerulean Blue.)

4 CREATE CONTINUOUS BRUSHSTROKES

Don't use a tiny brush which will have you constantly dabbing. It will be too slow, and it will look blotchy. Use the largest brush that fits in the shape and make continuous smooth strokes that draw clean edges.

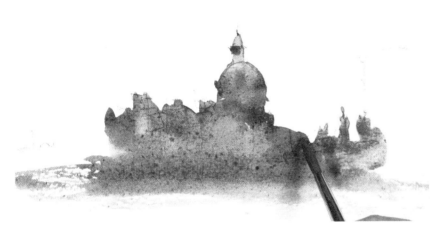

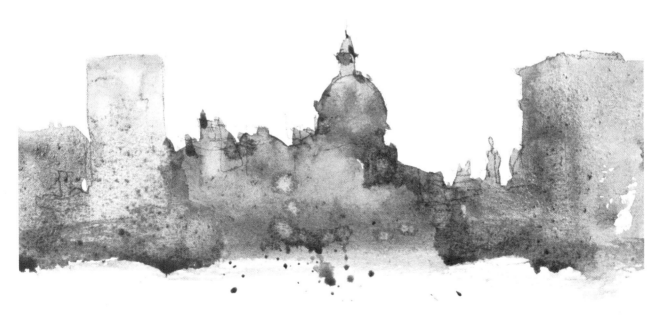

Completed Color Sketch

Charging-In Technique

· ·

Charging in is a British term that describes the concept of loading the brush with strong pigment and injecting it into an existing wash. You can use small touches of charging-in to accent intersections, enhance edges or add weight to undersides of small forms. This technique is easy to try, but takes some experimenting to master. You just have to jump in and start trying it, and eventually you'll get the right balance of pigment vs. water. With practice, it becomes instinctive.

Materials

140-lb. (300gsm) cold-pressed watercolor paper

round brushes of various sizes

watercolor pigments

paper towels

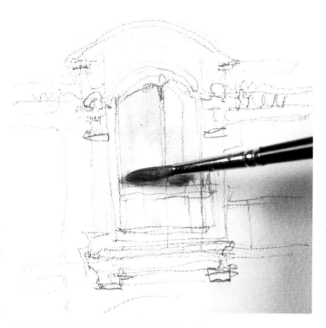 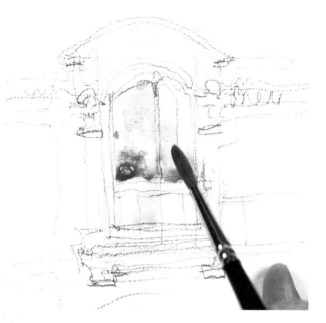

1 LAY COLOR INTO THE BASIC SHAPES

Start by drawing the wet shape you want to charge into. It would normally be in color, but in this example I used dirty water so you can see the injected pigment. Pick up a rich mix of strong color with the tip of your brush and touch it into any wet shape. The water that is already on the page will draw the new pigment in. You get a nice blooming effect of color as it flows into the shape. Do not blend or brush in. You want to let the water pull in the pigment, so the blending effect is organic. Don't attempt to smooth it out. Let the watercolor do the work.

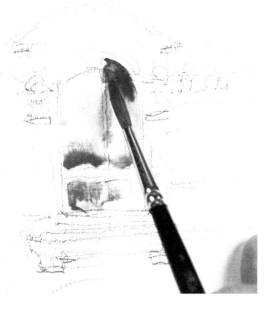
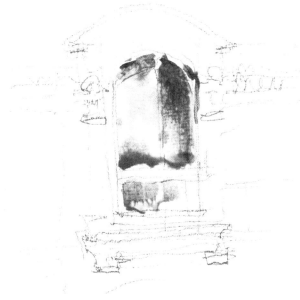

2 PLAY WITH BRUSH EFFECTS WITHOUT BLENDING

The more water involved (the bigger the brush you're charging with) the further the bloom will travel. You'll get different effects with different proportions of pigment to water, and there will be interesting interactions with the paper texture. Some pigments are granular, meaning they have heavier particles that make mottled effects. Others are more transparent and will make subtle glazes or bright clear blooms. These are all things the watercolor does for free. Don't overpower these natural results by forcibly blending your strokes.

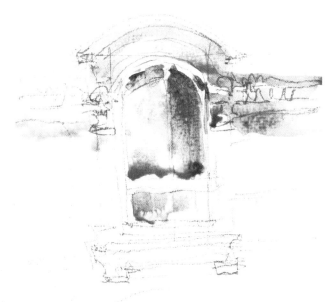
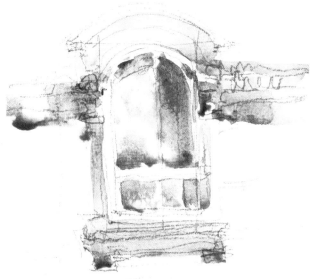

3 CONTINUE PAINTING COLOR INTO THE SMALL SHAPES

If you have a small thin shape in your composition, sometimes it's useful to draw over it with a pale wash, or even with clear water. That way if you don't get the shape right, you can just wait for it to dry and try again.

You can add color variation to even the smallest wet shapes without losing their contours because your touches of color will mix freely inside the live area, but stop at the dry edge.

Demonstration

Edge-Pulling Technique

There will be times when you'll want to soften an existing edge. You can do with clear water, as long as the wash is still alive. The goal is for one side of the shape to have a hard edge, while the other side is soft. I call this maneuver *edge-pulling*.

Materials

140-lb. (300gsm) cold-pressed watercolor paper

round brushes of various sizes

watercolor pigments

paper towels

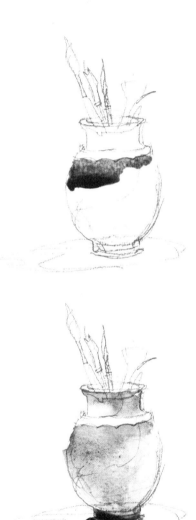

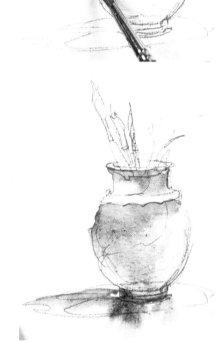

1 LAY WATER NEXT TO THE EDGE

Place a rich stroke of paint on the sketch. Before it is dry, lay clear water next to the edge you want to pull—not on top of your stroke of paint, but beside it. You are creating a little escape route in the direction you want the gradient of color to move. Very wet paints will bloom swiftly into the new territory. Nearly dry washes will creep slowly. Timing and how wet you are working will determine how much flow you'll achieve.

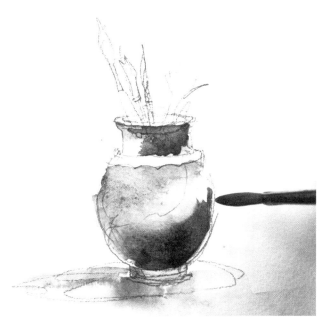
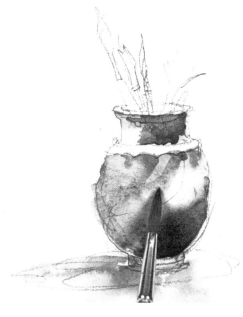

2 LAY IN GRADIENT SHAPES

There might be times when you might want to intro-
duce a gradient shape on top of an existing dry form.
Typically this is done when casting a shadow across an
object, or to round off forms like this brush jar. Remem-
ber that the first color must be dry! You want to control
where the color goes with your clear-water pull. This is
different from charging in. You are not after a generic
expanding bloom; you want to control the shape and
direction of the pigment flow.

3 FINISH WITH FINE DETAILS

You can do some very precise drawing with edge
pulling. It's possible to soften just a small part of tiny
form with a delicate touch of clear water. Use a few
more tiny edge pulls to draw details, (in this case, the
set of scalloped grooves on the body of the brush jar),
and to touch up the rounding-off effect towards the
outside edges. Sadly, If a wash has dried down, it can't
be moved in this elegant manner. This is why it's best to
work each shape one at a time, while it is still alive.

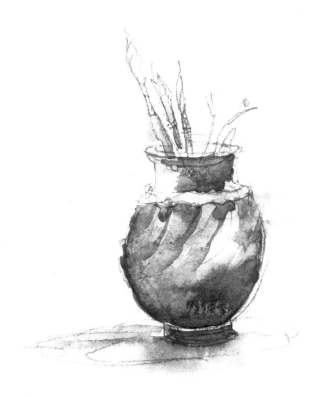

Completed Color Sketch

Demonstration

Splatter Technique

Sometimes you'll want to just throw in some random bits of paint, mainly because it's fun. Flecks and random dots of color can add a bit of visual excitement that you can't do by hand. You can use splattering to create texture on rocks or fabric patterns, or to transition from one area to another. It also works well for the leafy edges of trees. The only "trick" to it is getting the splatter to go where you want it.

Materials

140-lb. (300gsm) cold pressed watercolor paper

round brushes of various sizes

watercolor pigments

paper towels

1 LOAD AND TAP THE BRUSH

To get the brush flinging a nice spray, load it up with a juicy mix of paint. Then sharply rap it against your finger, about an inch or two above the paper. The sharp tap abruptly stops the brush and flings paint off the fibers. If you're worried about paint splattering where you don't want it to, put a bit of paper over the area you want to keep clean (covering someone face for instance). But you can get quite good at aiming with a little practice.

2 CORRECT AS NEEDED

If you over-do it, you can use water to merge some unwanted splats into a wash, or lift any unnecessary specks with a bit of paper towel.

Demonstration

Drybrush Technique

There will be times you'll want to create textured brushstrokes. Use a drybrush technique on those occasions. This one is fairly simple.

Materials

140-lb. (300gsm) cold-pressed watercolor paper

round brushes of various sizes

watercolor pigments

paper towels

1 MANIPULATE THE BRUSH SHAPE
Get a mix of strong pigment and water on your brush, with just enough water to make it flow. Then wipe away most of the color into a piece of paper towel so the brush is mostly dry. Splay the brush fibers out by stabbing and twisting the brush against some scrap paper or your palette.

2 CREATE TEXTURED MARKS
Draw dry, scratchy textured marks with the resulting broom-shaped brush tip. This comes in handy for trees and rough stone buildings. Don't be afraid to stab or grind with the brush. It won't damage the brush as much as you think. The fibers are tough. I do it all the time, and my brushes still last for years.

Painted Sketchbook: Line & Wash

Of all the painting media you might choose, watercolor is the most closely associated with sketching. By its nature, being portable, transparent and fast drying, it's ideal for accenting drawings.

The main advantage of transparent watercolor is all the fluency you already have with calligraphic drawing and spotting black inks. The skills you mastered while making eloquent drawings should not be put aside when you move to color. The sensitivity and confidence with line that sketchers enjoy can be made a key part of color work. Transparent water media can embellish a drawing, add life and emotion, and allow a more complete story to be told without giving up the handwriting of your sketch.

This will start you on the transition from drawings to painted sketchbooks without asking you give up the things that brought you to sketching in the first place. It will give you practice with paint consistency, mixing color and composition. It's common for beginners to use too much water, ending up with pale sketches. This is a great way to get an instinctive feel for the right proportion of paint vs. water. Begin by simply adding color as a fourth pass on top of an ink drawing.

Transition Between Tone and Paper

Make a bit of a transition between tone and paper. Think about the design of the white shapes you are leaving and how the color fades off. See how in this drawing some of these wet shapes (the gutter under the potted plants and the shadow inside the entrance to the café) have been edge-pulled with clear water, just by dragging a little pigment out of the shape to make lighter tone blending into the white paper. It's a great way to add life to the scene, and it's easy to do in the field with a small paint kit.

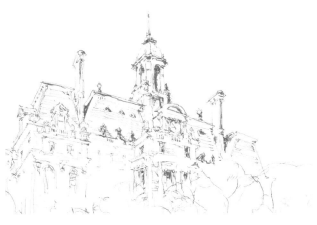
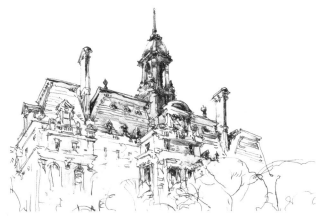

Fade Washes

In this type of sketch, I like to make a vignette, that is, allow the colored washes to fade off to the white of the page. It lets a sketch remain a sketch. The drawing is still the star, but now with a splash of excitement. This might be only a question of taste, so try it for yourself.

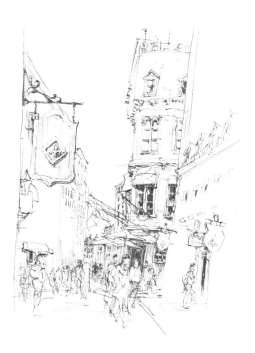
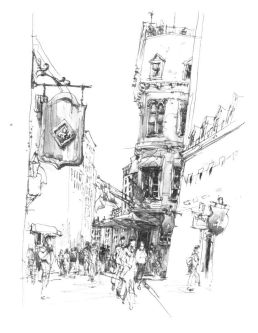

Establish the Gradient of Interest

Start with a clear idea for the subject of the drawing. Begin at the focus and work out, establishing the gradient of interest. When it comes time for spot blacks, slow down and go at the darks with a light hand. Leave some room on the value scale for the fourth pass of color.

Place your color right on top of the darks, growing outward from the dark focal areas. This way your colored shapes won't contradict the gradient of interest. These selective accents of color are strong eye magnets. Make simple clean-edged live shapes. Control the wet/dry edge, to draw the shadow shapes, or the areas of local color. You don't need have perfect brush control. The line is doing the descriptive work.

Your spot color doesn't need to be complex to do its job, but this is a great time to experiment with charging in and pulling edges. Note how a few spots of pure Cerulean Blue (the panes of the windows and the awnings) have been dropped into a stone-colored wash. Where edges touch, the charged colors make some pleasing effects floating into the larger wet shape. You can see how these simple color notes already begin to inject life into the image. Even one of these colorful eye magnets on a page brings excitement to a sketch.

Exercise 16
Spot Color on Portrait Subjects

Hopefully you'll be able to see the familiar principle of spot blacks at work in this exercise. You're already well practiced with seeing the pattern of shadow shapes. Now it's simply a matter of applying the same thinking to making shadow shapes in color.

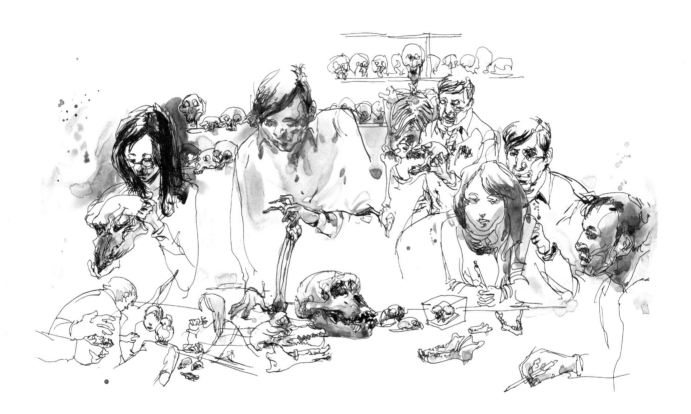

Use Warm Tones Expressively
When dealing with humans subjects, the internal washes can be charged with any flesh tone or warm colors. I've found the actual color isn't really all that important. So long as the shadow shapes are right, any color will do so long as it's used expressively. After all, a sketch is your personal interpretation. Don't hesitate to inject some vibrant tones. (I often accent with Cerulean Blue or Holbein Lilac.) It's not a matter of making a perfect copy of life, but of interpreting, even exaggerating what is there.

1.

2.

3.

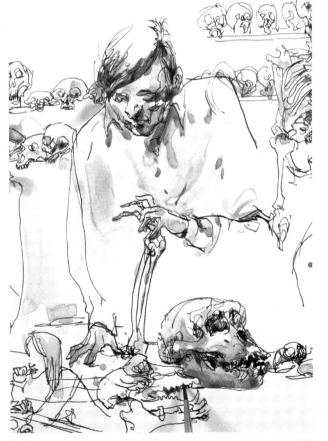

4.

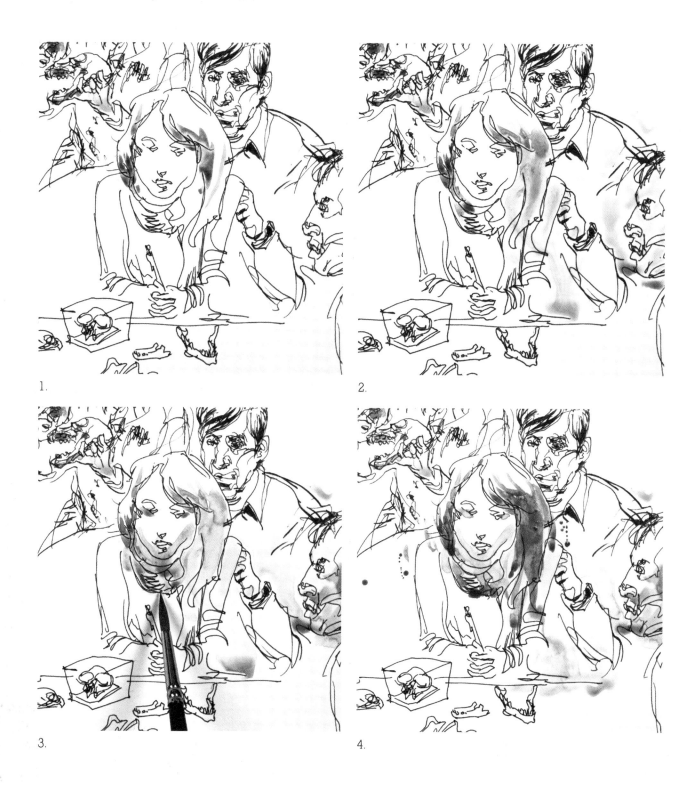

1.

2.

3.

4.

Visit artistsnetwork.com/theurbansketcher to access bonus lessons.

Finding Subjects

The quest for new subjects is never ending. If you want a dry run at doing this in a controlled situation, you can probably find a life-drawing class at a local college or art school. I got these sketches by attending an anthropology class at the local university. Friends in the department graciously arranged for me to be a fly on the wall. This exercise would also work very well with sculptural subjects. I'm in favor of any excuse to go drawing at the museum or the graveyard, but you can also do this with any statue in the park.

Exercise 17

Large Washes: The Three Big Shapes

There is nothing wrong with sticking with spot color for the rest of your career. The beauty of line and it's elegant shorthand summary of reality is an art form with its own subtleties and lifelong learning curve. But, there is also the impulse to work towards painting, as opposed to drawing. That is, fully painted tonal images rather than tinted linear drawings. This exercise should help you make the transition from accenting a sketch to doing complete paintings.

As you begin to use more paint and less line, you'll have to consider what you'll describe with the colored shapes, and what you let the line handle. Naturally the line is more suited to detail, and color washes can cover more area. Think of the drawing as the bones and the color as the skin. This leads to the principle I call the *Three Big Shapes*.

Think of an imaginary simple sketch: a small house on a lawn with blue sky above. This theoretical sketch could be divided into three shapes: the sky, the ground and the silhouette of the house. Each of these big shapes should be given its own color. They should read as a big shape inside the composition.

In reality it's never exactly that simple. There are often many more than three shapes in sight. But we can use this concept as a way to remind ourselves to see simplicity. Use as much as you need to capture the scene, of course, but the goal here is to see how few shapes of color you can get away with. Practice with visualizing the big shapes, simplifying the scene into as few blocks of color as possible. Letting the drawing convey the detail, while the color defines masses.

Three Big Shapes Line
This sketch of a café in Havana is organized into eight shapes. Decide in advance where your wet/dry edges will be. Each shape will be handled in one wet wash, with the wet/dry edge following the ink lines.

Visit artistsnetwork.com/theurbansketcher to access bonus lessons.

Shape Plan

Ask yourself if there any shapes that can be merged together. Where can complex shapes (like the umbrellas and chairs) be simplified into a silhouette? What internal details can be abstracted out? (Note the fade-away of detail in the background building on the far right and the wall in the left foreground.) Areas of less importance in the linework should also get less interesting washes. Your big shapes of color should respect the gradient of interest created by the line work.

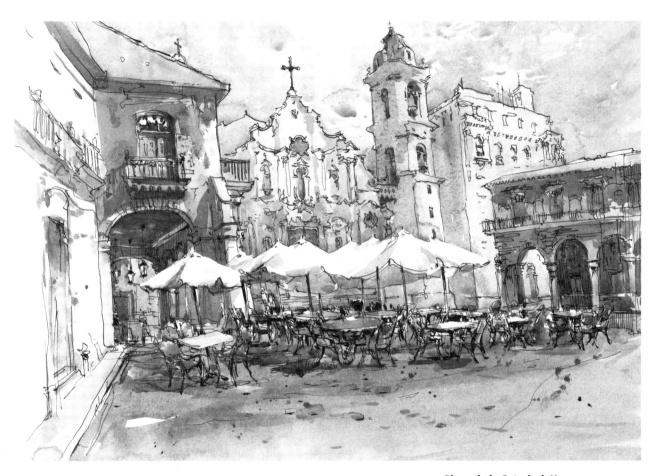

Three Big Shapes Tone

Aim for color variety inside each shape. Use charging in, wet-into-wet effects. This sky is a good example of growing a wash. Each stroke fuses with the one next to it, but each time I went back for color, I modified the mix, changing the proportion of my sky colors (mostly Cerulean Blue and Holbein Lilac) with touches of the leftover dirty pigment from the corners of my palette to "gray off" the bright pigment.

Plaza de la Catedral, Havana
14" × 20" (36cm × 51cm), Pen, ink and watercolor on Arches 140-lb. (300gsm) hot-pressed block

Three-Pass Watercolor Sketch

Everything we've done so far with three-pass sketching process has been leading up to this. We have been drawing with pencil > pen > brush in the sequence of scribble > calligraphic line > spot black, to which we have recently added spot color. In the following demonstrations, you'll see how my approach to painting in watercolor is basically the same philosophy, just repurposed for working in color.

When doing a watercolor painting as opposed to tinting a sketch, leave out the ink line. The ink line is too powerful to remain in a painted piece. You're after a more subtle, tonal representation. Still do a pencil sketch, however. Keep it light and reasonably accurate with clean unshaded lines and no hatching. You want to be sure everything is in place, and that you understand the details you're going to paint.

Work in three passes of painting, from lighter to darker and larger to smaller. I call these three passes (or three steps) Tea, Milk and Honey. These directly relate to the scribble > calligraphy > spot black steps. In each of these watercolor stages, you'll do as you did with three-pass sketching, but now, you're working with tone-on-tone rather than in lines. Each pass of color covers what went before, building strength and solidity (and creating the gradient of interest) by overlapping transparent layers and by using more pigment and less water in each step. I like to think of the liquids tea, milk and honey as a shorthand reminder. Each liquid is a practical example of the paint viscosity you are aiming for—the "tea" being very fluid, a wash. The "milk" is partially opaque, using less water and more pigment. The "honey" is the last rich sticky mix of pigment applied with relatively little water.

Materials

140-lb. (300gsm) cold-pressed watercolor paper

round brushes of various sizes

watercolor pigments

paper towels

Line Sketch

The pencil sketch can be a rapid scribble or a more careful study, depending if you want to capture an accurate view, or are just after a spontaneous impression. It should be as minimal as possible. Just the key details and nothing more. You should already be thinking about the big shapes, drawing outlines of the blocks of color, and sketching shadow shapes—all the small forms inside windows and under balconies. Also think about how the detail will fade away from the focal points.

Visit artistsnetwork.com/theurbansketcher to access bonus lessons.

First Pass: Tea

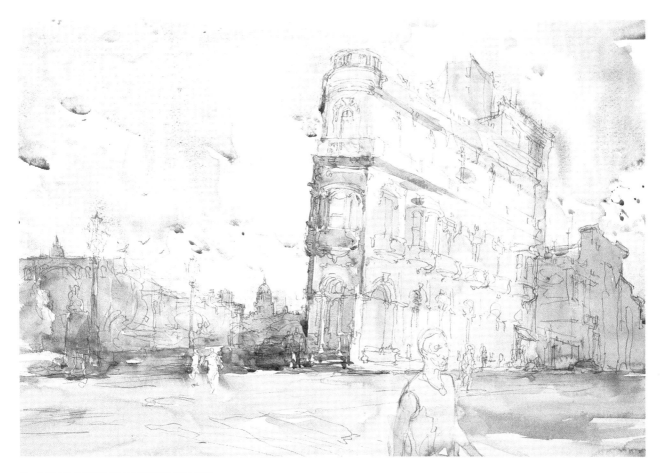

1 LAY DOWN THE FIRST WASH

In the first color pass, pour the "tea" into the big shapes (sky, shadowed block, flatiron building, background buildings and foreground street) just as you did when tinting your sketches. The block on the left side in the shadow of the building is a great example of growing a wash. There is plenty of internal color variation, but the edge of the wash is sharply cut against the sky. Each major shape will have a dominant local color, but don't let it be monotonous. Grow an interesting wash inside the shape. Fuse in complements and color variations each time you go back for pigment. Bring some of the colors from the sky into the shadow areas so the shapes are harmonious.

Work quickly enough that edges of live shapes can merge if you allow them to touch, such as where the flatiron building touches the orange block behind, or the sky above. (Or where the shadowed street touches the lit foreground pavement.) Only allow live shapes to touch where you want them to blend, keeping a hard edge along the skyline. If you work too slowly things will dry up as you go, making hard edges everywhere. This is why you want to use the biggest brush that fits in the shape, and why you need a larger palette for larger works.

The tea mix needs plenty of water. It should flow freely and tint, but not obliterate the drawing. Yet it should not be so pale that the shadows seem weak once applied. This is a judgment you'll just have to learn by practice. Not too light, not too dark. Aim for the lightest local color inside the object. A black car for instance, will have a dark lightest local color. An off-white building such as the main subject here has a much lighter local color. See how the tea on the shadowed car and distant block is dark in comparison?

It can also be tricky getting the right value of local color in the tea wash, due to the nature of diluted watercolor "drying-upwards" (lightening in value). A good rule of thumb is, the more water in the wash, the more it will lighten as it dries.

Avoid the brightest whites, such as the whites of clouds in the sky and the tiny white slivers left around the front entrance and balconies, leaving them as white paper. These are important glints that will create the illusion of lit edges on the architecture. If you're not careful with cutting these small shapes, you might have to come back with touches of gouache later.

Second Pass: Milk

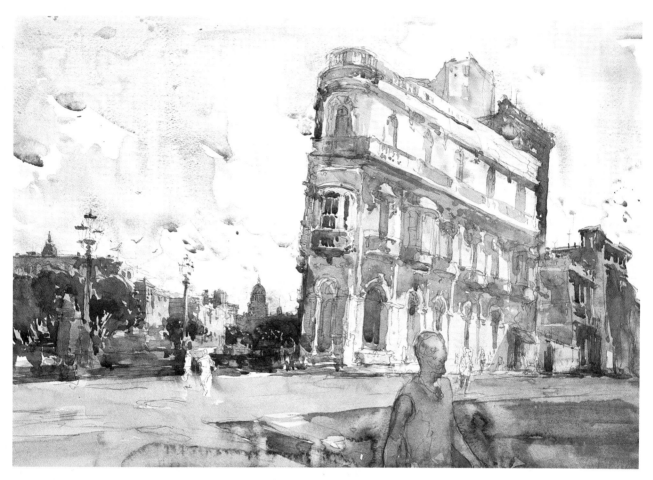

2 APPLY THE SECOND PASS OF COLOR

The second wash, the "milk," needs enough pigment to be cloudy in order to cover what has gone before. As you work from lighter to darker, you'll only need to deepen midtones and shadow shapes. (Isn't it clever how you're using the skills introduced in the very first pencil exercises?) Anything that is in the light shapes does not need to be touched. The light values show through the pattern of shadows placed on top. The sky and the lit
side of the building will remain as the tea all the way to the end.

Work the shadow shapes with calligraphic brushstrokes. Don't completely fill your shadow shapes with color. The small glints of tea that show through the milk, are important. See how the tiny gaps in the second wash draw the trees over on the left? Or help create window frames, bannisters and doorways? What you leave out, is just as important as what you touch. You are drawing with negative shapes. Keep them lively and fresh. It's just like spotting with black ink, but with a greater complexity of values. Each pass should be faster than the one before. Do only as much work as is necessary to build up the dark shapes.

Please note: It is crucial to let the paper dry between passes so you have the most control of edges. On a nice day, just put your sketch in the sun for a few minutes to dry. And you can always start a second sketch while you're waiting for the first one to dry.

Third Pass: Honey

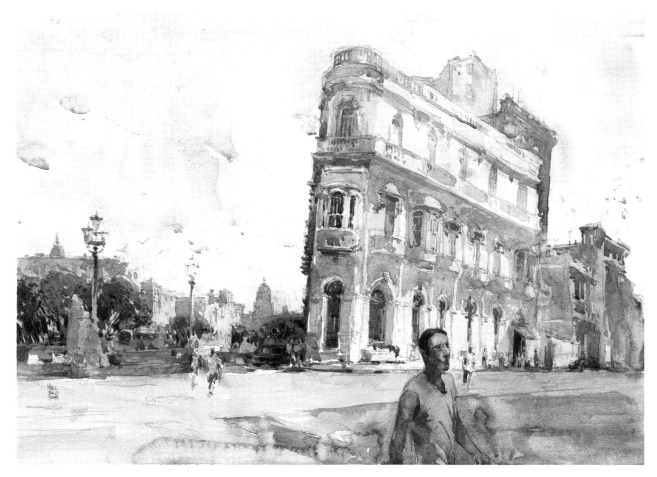

3 FINISH WITH THE THIRD PASS OF COLOR

The third wash, the "honey," is a very rich mixture of pigment, with just enough water to allow it to flow off the brush. It should be viscous, slightly sticky, and should appear almost opaque on the paper Essentially you are making ink with which to spot black. But with watercolor you can make complex darks by combining warm and cool colors for variety. You can also fade out the intensity of the darks towards the edges, or make good use of edge pulling to draw smooth gradations out of these dark touches.

Malecón, Havana
Pen, ink and watercolor on 140-lb. (300gsm) cold-pressed watercolor paper, 15" × 22" (38cm × 56cm)

More Three-Pass Sketching with Color

Let's get some more practice! Sketch another scene, using the three-pass method of applying color. This scene was at midday with the sun behind a thin haze of cloud, making for a generalized glare everywhere and a washed out sky.

Materials

140-lb. (300gsm) cold-pressed watercolor paper

round brushes of various sizes

watercolor pigments

paper towels

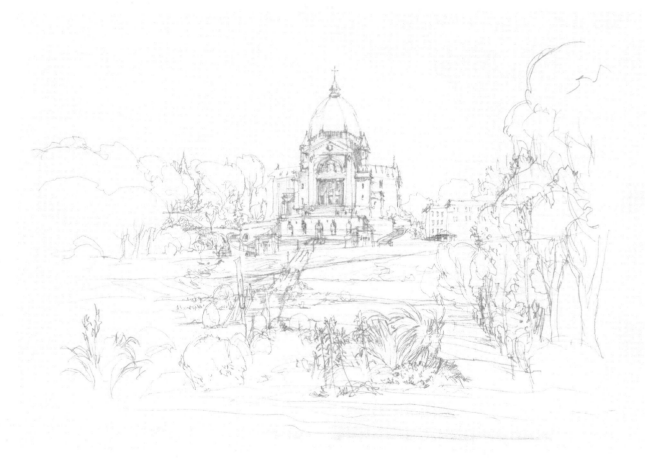

Line Sketch

Knowing that I am going to do most of the work with watercolor, I don't put more effort than necessary into the drawing. Just a clean pencil drawing that's fairly descriptive, and including with the major outlines of color shapes. It's important to me that the drawing not be too dirty with a lot of graphite. Unlike a tinted ink drawing, I don't want the linework to show at the end of the day.

First Pass: Tea

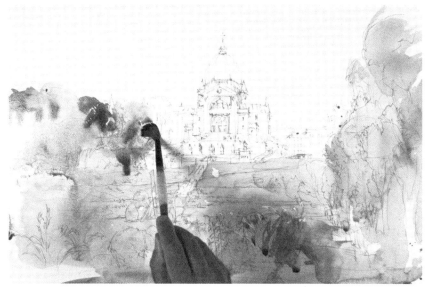

1 Apply the First Color Pass

Apply the first color wash quite quickly. Try to work the three big shapes in the image, wet-into-wet, staying loose and splashy with lots of color variation. At the same time, keep the dry edges between live shapes sharp. Do all this before the first live shapes dry. The entire image can sometimes be washed with tea in five minutes or less. The combination of swiftness (to get it all done while it's wet), and accuracy takes some practice. Keep aware of your color variation, going back for a slightly different hue every time Never use just one color. Always modify the base color with warm and cool neighbors.

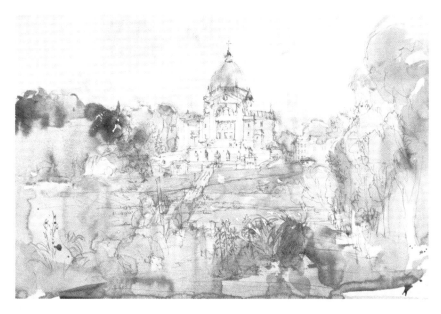

The Finished Tea Stain

The entire surface of the painting has been washed. I left a few small flecks of white throughout the midground to create random glints. Washes should never be too smooth or too perfect. Even if those stray gaps don't represent specific objects, tiny irregularities add visual interest.

I should have hit a richer color in the sky; it's too pale. Also, the warm white of the stone building is too bleached out. Mostly, though, you should accept whatever happens at this stage. Don't beat yourself up about washes. The joy of watercolor is enjoying the effects of fluid dynamics. And in any case, you'll cover what matters with future passes. Here, I went back and added some more tea to the church building before I finished. You don't have to stick to exactly three passes. Sometimes you'll want to touch up an area. Don't let the rules hold you back; they are guidelines you can break when you need to.

Second Pass: Milk

2 APPLY THE SECOND PASS OF COLOR

After the first pass has dried, proceed to the second pass of color. Work the midtones and shadow shapes. Leave the lit areas alone; let the tea stain glint through. You don't want uniform coverage like you're painting a wall. You want to create a light-dappled texture, letting the layers interact. Allowing little gaps in the second milk pass will create the illusion of light bouncing off the upward-facing surfaces. I like to say it's like a lace dress—what shows through is just as important as what is covered.

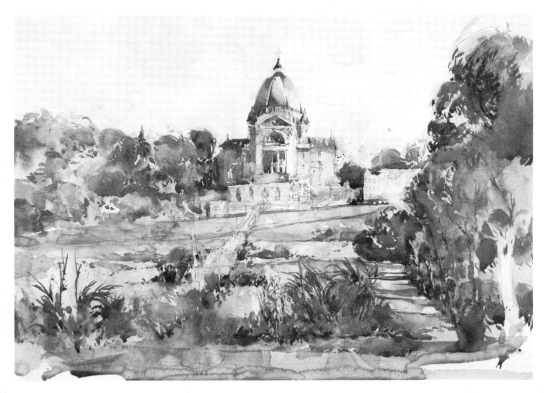

The Finished Milk Stain

Note how dark the milk is in the trees. Foliage can often appear black in a sunlit situation. The leaves are full of small shadow shapes, whereas the ground is reflecting light towards the sky. Trees are usually the darkest things in a scene.

Don't hold back on the pigment, thinking you need to save it all for the final color pass. Remember how little honey there is in a cup of tea—the darkest darks are only for the final pop of contrast in the eye magnets.

This stage is the most fun for me. There's a lot of exciting brush calligraphy and charging-in to make the shadow shapes and mid tones. I also love the random energy of flicked paint created by splatter.

Visit artistsnetwork.com/theurbansketcher to access bonus lessons.

3 PULL EDGES

Don't forget your edge-pulling technique! Here, I brushed a dark green line to ground the foliage in the flower bed. What followed was a classic edge pull—clean water, laid parallel to the wet stroke, barely touch-

ing it. This caused color to be sucked down into the new water. The result was a much more interesting dripping edge than you can paint by hand.

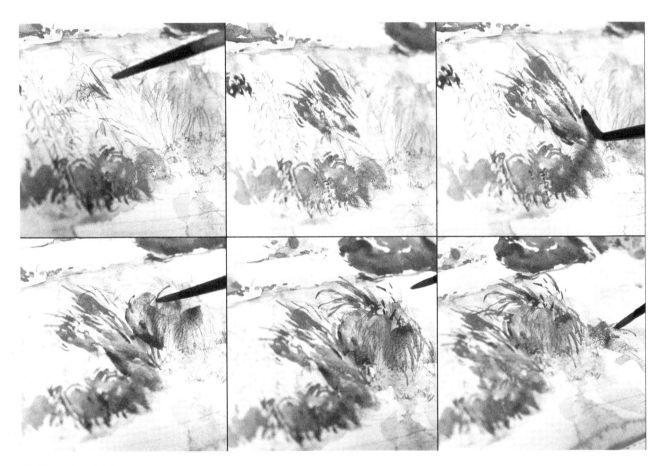

Calligraphy Grid

Here's a sequence in which I drew the sharp spiky shapes of the foreground foliage. I had a rough map in the pencil drawing, but (just as with calligraphic ink line) I didn't attempt to trace it closely. I sketched the silhouette edge formed by many overlapping leaf shapes and mingled wet-into-wet color inside the masses. Each clump of plants has their over-

all color; one is warmer, one cooler. Always alternate color temperatures with adjacent objects in order to separate forms. Note that I only did the silhouettes of the plants, as I knew they would be shaped by the dark cast shadows coming up in the next pass.

Third Pass: Honey

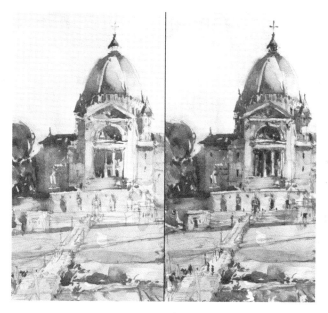

4 APPLY THE THIRD PASS OF COLOR

Now it's time to add the third pass of color. If you think about my analogy for a moment, there is only one teaspoon of honey in a tea cup. It's the same for these darkest darks—not too much! They are only two or three percent of a typical sun lit image. Even when your subject is dark and shadowy, the spot blacks are only for the deepest contact shadows. A sketch doesn't really come together until these darks are properly placed, because they are the basis of the gradient of interest. We know the weight of the darkest darks attract the eye. In a smaller sketch, especially a vignette, there can only be one focal point. In a more complex painting like this, the viewer's eye will travel from eye magnet to eye magnet, moving around the pictorial space.

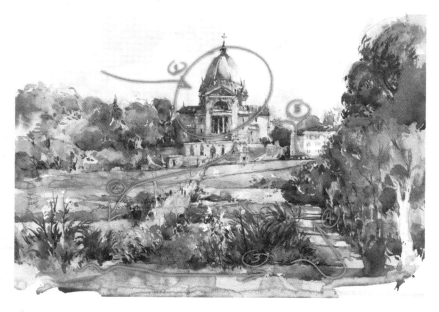

Composition Diagram

The strong shape of the dome against the sky is the most powerful part of the painting—the sharpest contrasting edge, the boldest graphic shape, the climax of the story. The rest of the composition is designed to move you around the space in the foreground. The viewer travels from the entrance of the oratory down to the details in the flower bed, across the strong horizontal base, and back up the row of trees. This visual journey through the space is the story we're interested in creating.

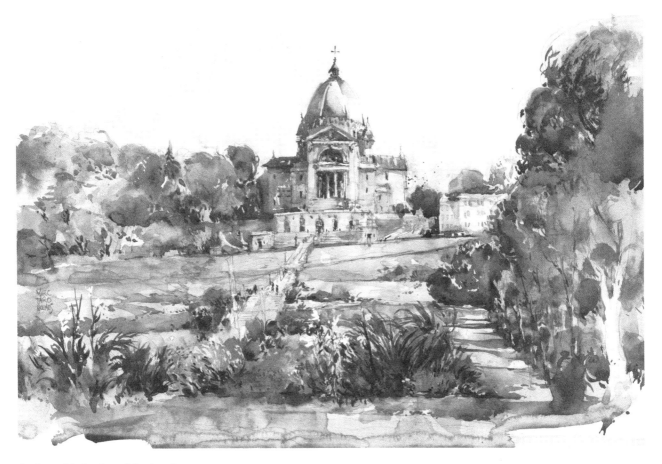

St. Joseph's Oratory, Montreal
Pen, ink and watercolor on 140-lb. (300gsm)
cold-pressed watercolor paper, 15 " × 22 "
(38cm ×56cm)

Opaque White

As a side note, the very last thing I did was put in some white lilies in the foreground. The honey stage is mostly about the deepest darks, but it is also your last chance to re-touch the lightest lights. I used white gouache mixed to a honey consistency to sketch in the lilies in the flower bed. You can tint white gouache with watercolor to make any high-key opaque color you might need. I never need many of these lightest lights, just enough to bring back things like reflected blue sky in windows, bright yellow/green back lit leaves, or the occasional tiny spots of intense color in street signage and people's clothing.

Exercise 18

Tea, Milk & Honey for Still Life Sketches

At this point, there is little left to be said except, *Go try it!* I hope I've completely demystified the art of sketching in watercolor. If you are struggling, don't worry— it is just a matter of becoming dexterous with the brush and practicing with paint mixing. Everyone can get there, simply by continuing to draw and having fun practicing. If you find yourself very frustrated, just go back to tinting over drawings for a while. Then simply begin to use less line work and more wash until you find yourself painting. This is a system that worked for me, so it is by definition foolproof!

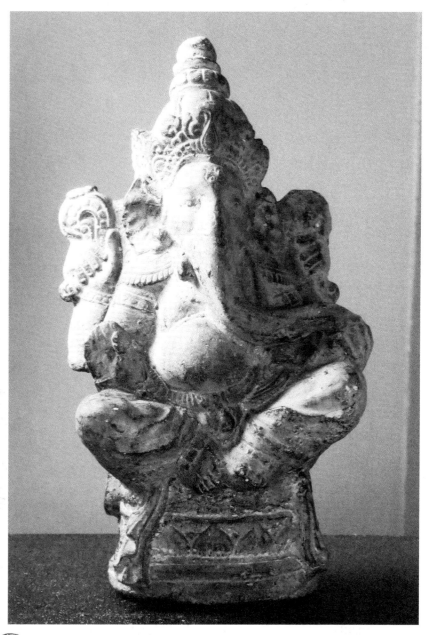

Choose Your Subject

I recommend starting under controlled circumstances. Try a still life subject at home, with no pressure of time or distractions. After you have a few of these, you'll feel more comfortable taking what you've learned out into the streets. For this example, we'll use a small statuette I brought back from the shop in Exercise 2. You could work with any interesting object—a vase of flowers, some old boots, or you could even do a self-portrait in the mirror.

The Line Drawing

As always, start with a line drawing (darkened here for clarity). Can you see here how I'm mapping out the shadow shapes I'll be painting later? It's almost like I don't draw forms at all, just the shadows they cast.

The First Pass: Tea

When doing an isolated object, there is only one big shape. So it's a simple matter to pour the tea. I've used some edge pulling to bleed the color outside the form, just to keep things looking softer against the simple white background of this study. Inside the wet shape I've grown a wash with plenty of color variation. I've made a warm to cool transition, so the shadow side is starting to appear, even without any detail. I've made numerous random charged colors, just by instinct, with no strict plan, simply that I know some will show through the upcoming shadow layer. I just want to create opportunities for interesting glints of color. Remember, like a lace dress, what shows through is just as important as what is covered.

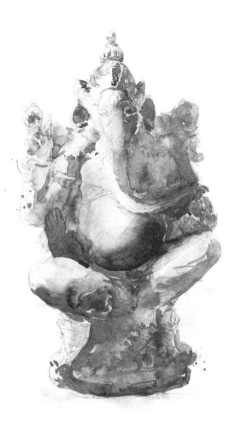
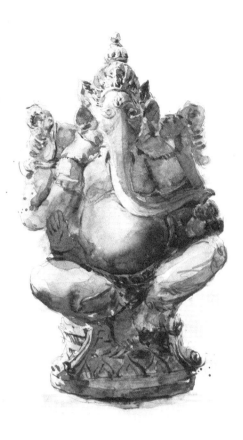

Second Pass: Milk

In this classical lighting situation, about half the object is in shadow, maybe a bit less. I am only touching these shadow shapes. The areas of tea lit color will not be touched after the first pass. Note the use of color inside the shadow shape. Even though in reality it is a uniform tone, I've used pools of exaggerated color to create internal forms. Particularly in the hands and crown.

 Also note the small open reserved shapes. I went carefully in the detailed areas, leaving glints of the tea showing through to imply the decorative relief carved surfaces. I like to switch between drawing some detail with the tip of a small brush, then swapping to a larger size to fill in the masses around. Note the use of edge pulling to make the fat round form of his belly. That's a classic case of using the wet-on-dry technique. I have a sharp edge where I want it at the belt line, and a soft, watery transition on the curve of the stomach.

Third Pass: Honey

In this example there's a lot more honey than usual. There are plenty of tiny dark shadows on this figurine. The detailed carving in the crown and on the base comes alive when the shadows appear. It's almost like doing a calligraphic line drawing on top of the silhouette forms. This is my favorite part: when the drawing pops and the form appears. See how these tiny strokes of dark make all the difference?

Recap of the Three Passes

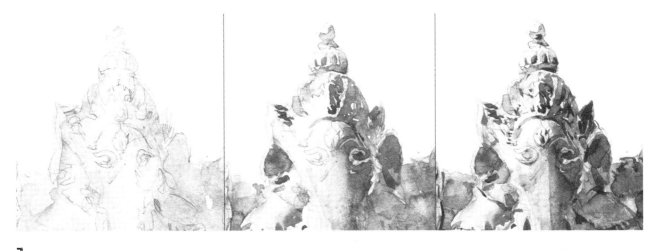

1

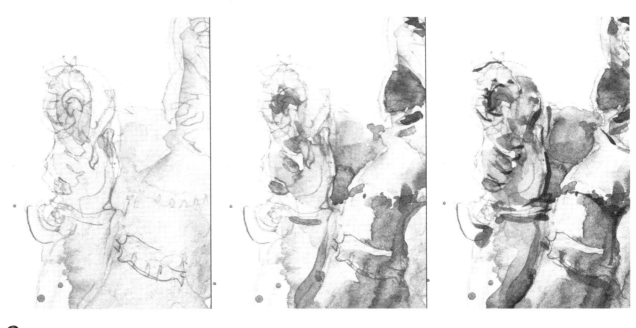

2

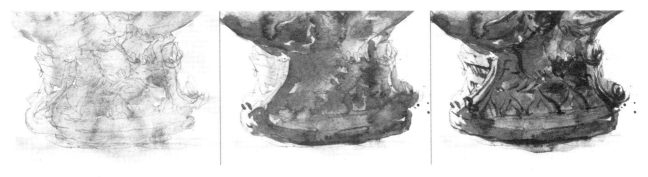

3

Gallery

Here are a few standout examples of urban sketching chosen from my collection over the last few years.

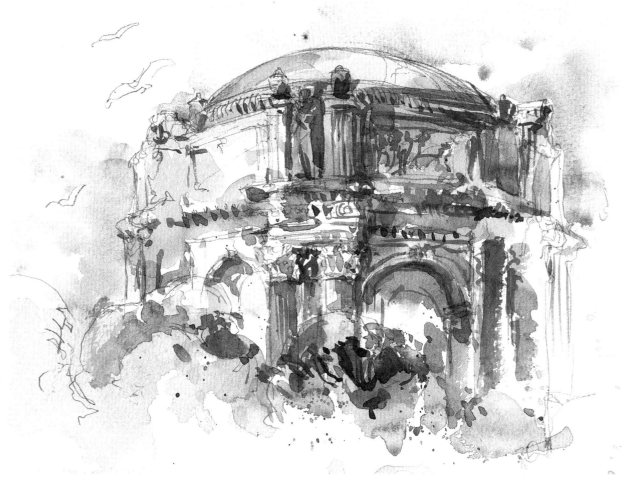

San Francisco Palace of Fine Arts
Pen, ink and watercolor on 140-lb. (300gsm)
Canson Montval block, 8" × 10" (20cm × 25cm)

Visit artistsnetwork.com/theurbansketcher to access bonus lessons.

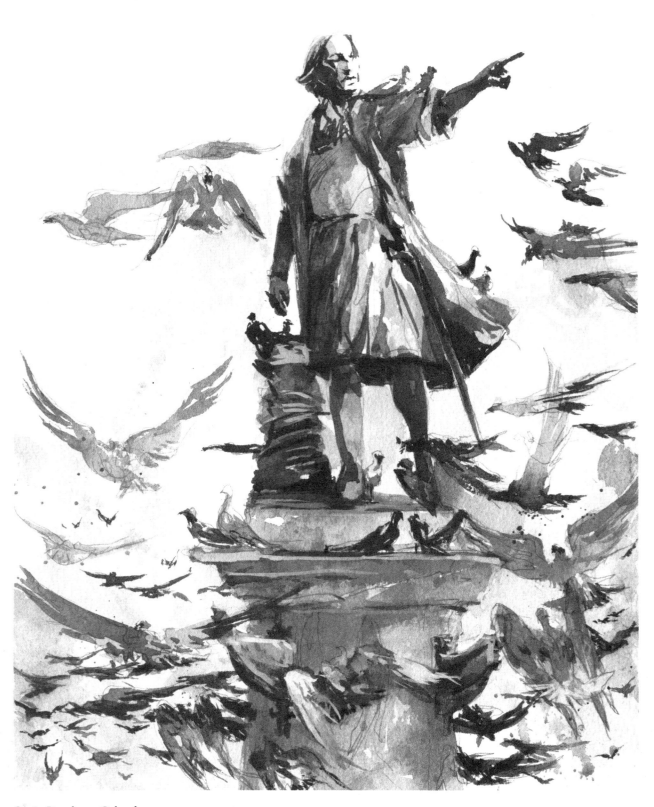

Santa Domingo, Columbus
Pen, ink and watercolor on 140-lb. cold-pressed
watercolor paper, 11" × 15" (28cm × 38cm)

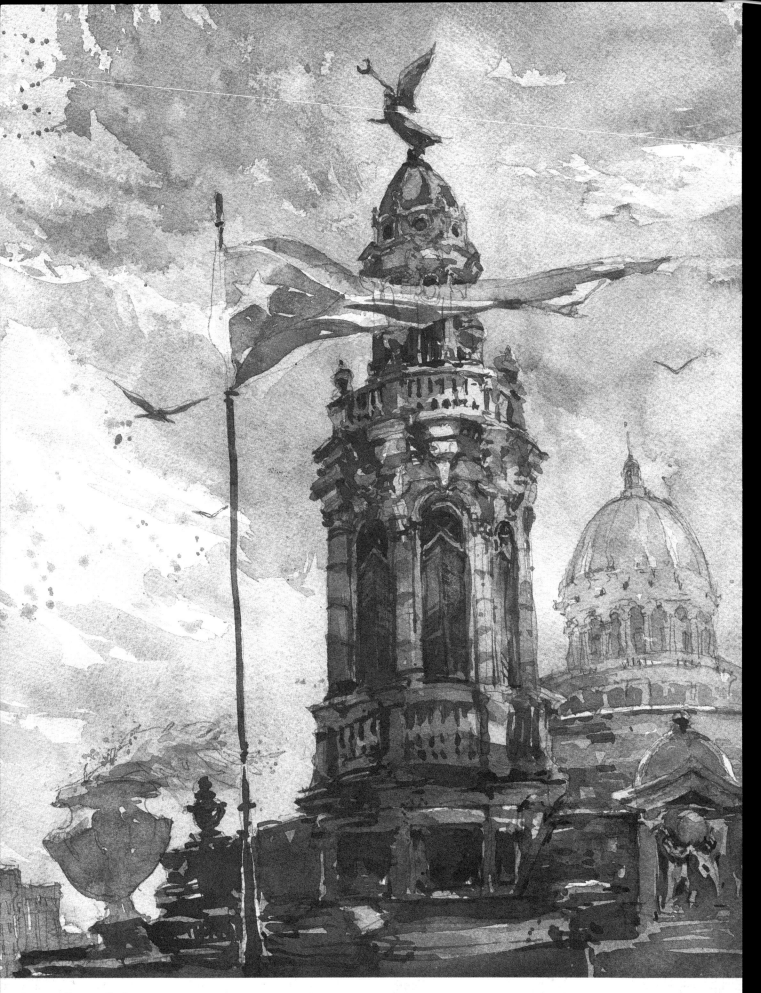

Havana Teatro
Pen, ink and watercolor on 140-lb. cold-pressed watercolor paper, 15" × 22" (38cm × 56cm)

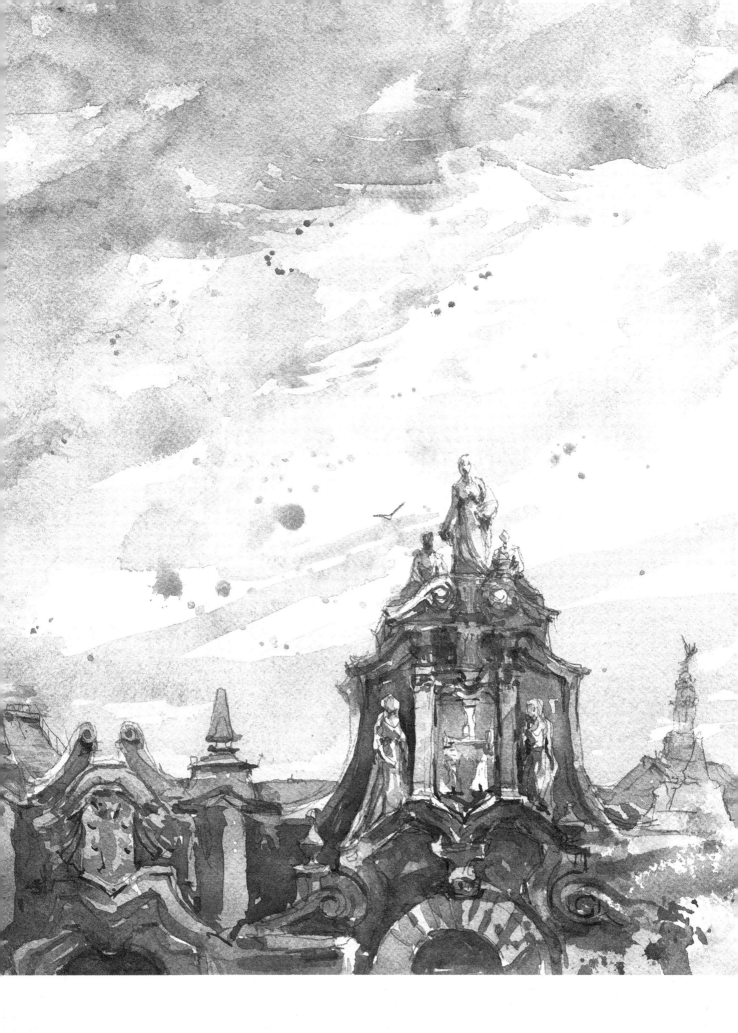

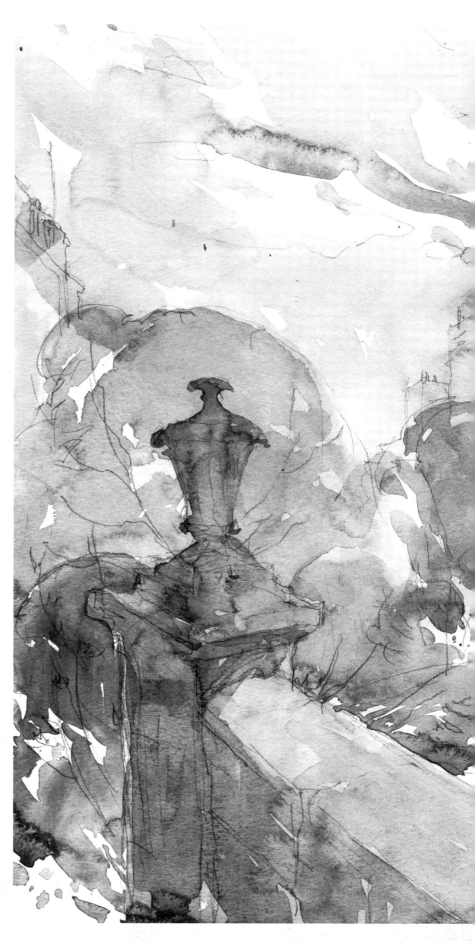

Meredith House, Montreal
Pen, ink and watercolor on 140-lb.
cold-pressed watercolor paper, 16" × 20"
(41cm × 51cm)

Visit artistsnetwork.com/theurbansketcher to access bonus lessons.

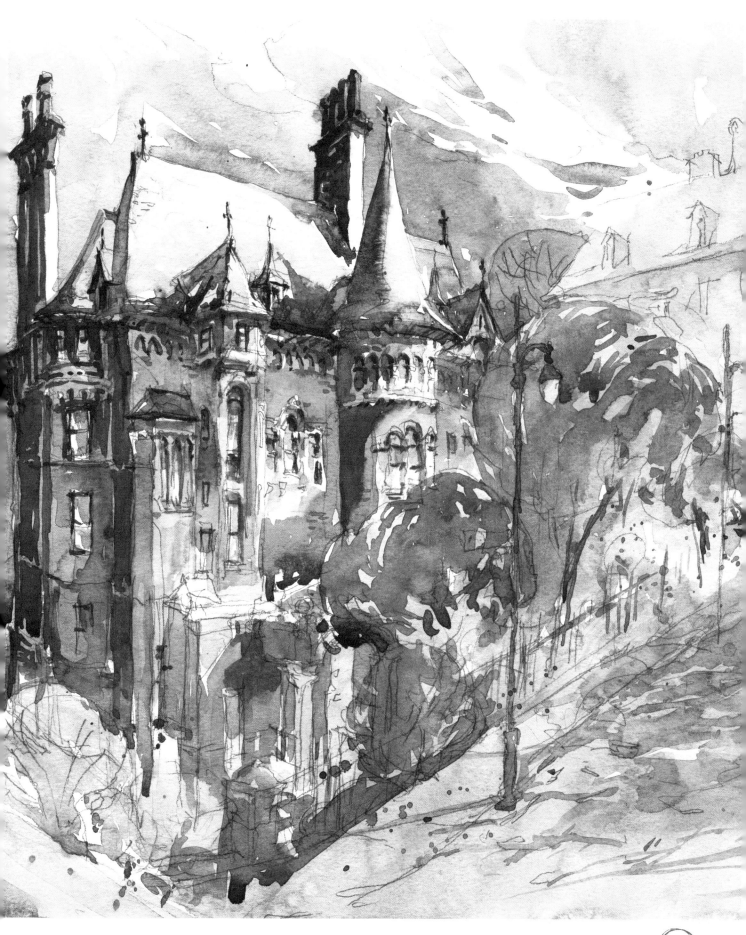

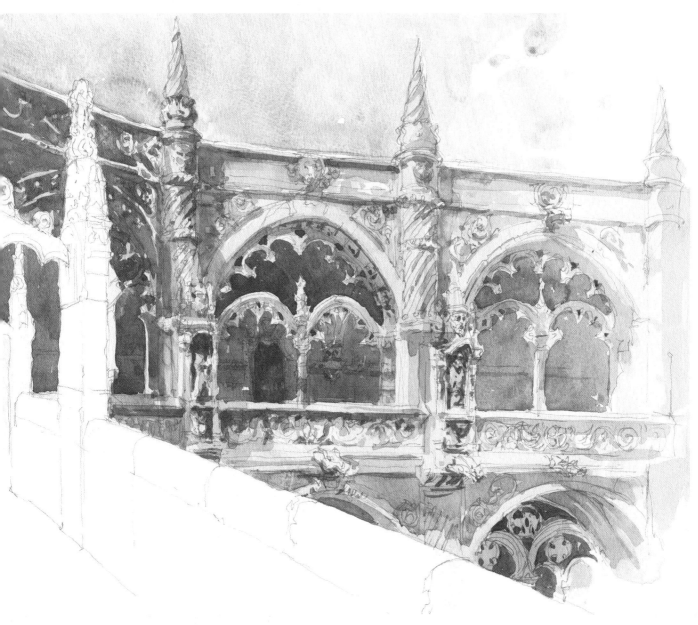

Lisbon, Jeronimos Interior
Pen, ink and watercolor on 140-lb. (300gsm)
Canson Montval block, 15" × 20" (38cm × 51cm)

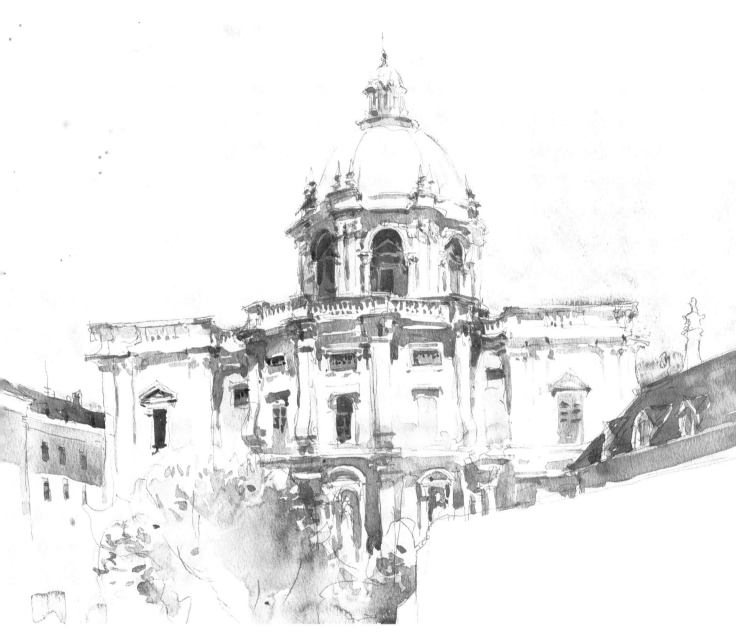

Lisbon, Santa Engracia
Pen, ink and watercolor on 140-lb. (300gsm)
Canson Montval block, 15" × 20" (38cm × 51cm)

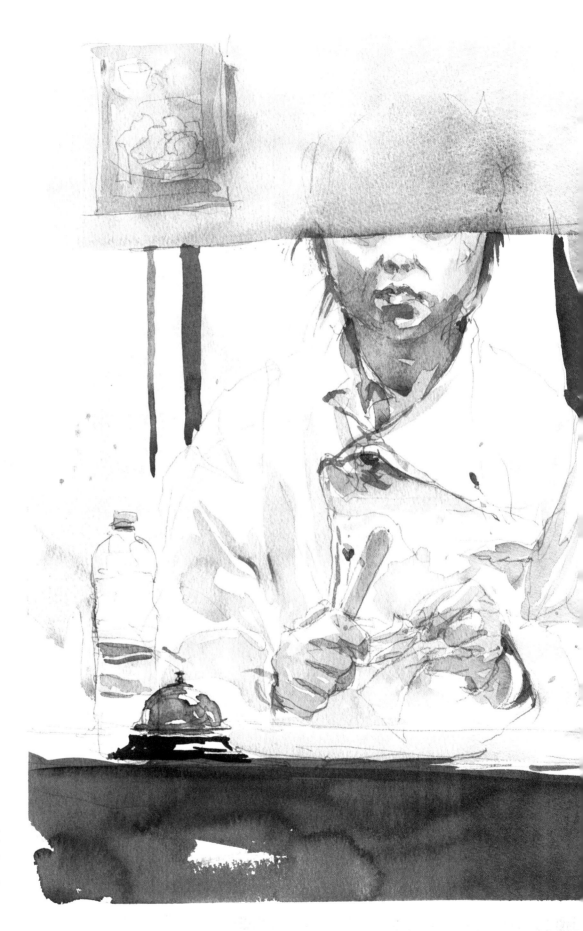

Montreal Dumpling House Cooks
Pen, ink and watercolor on 140-lb. (300gsm) Canson Montval block, 15" × 20" (38cm × 51cm)

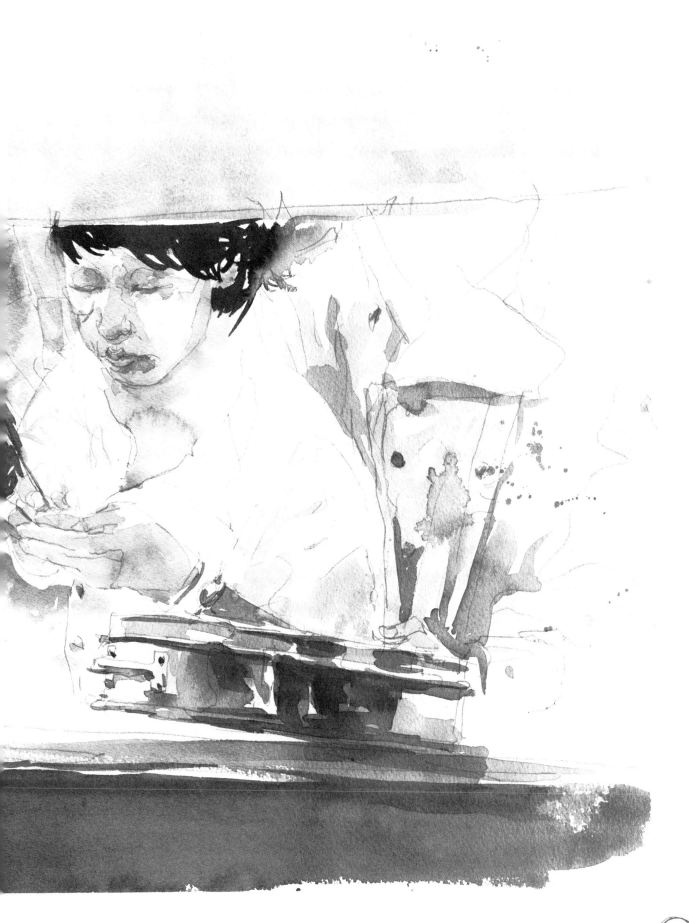

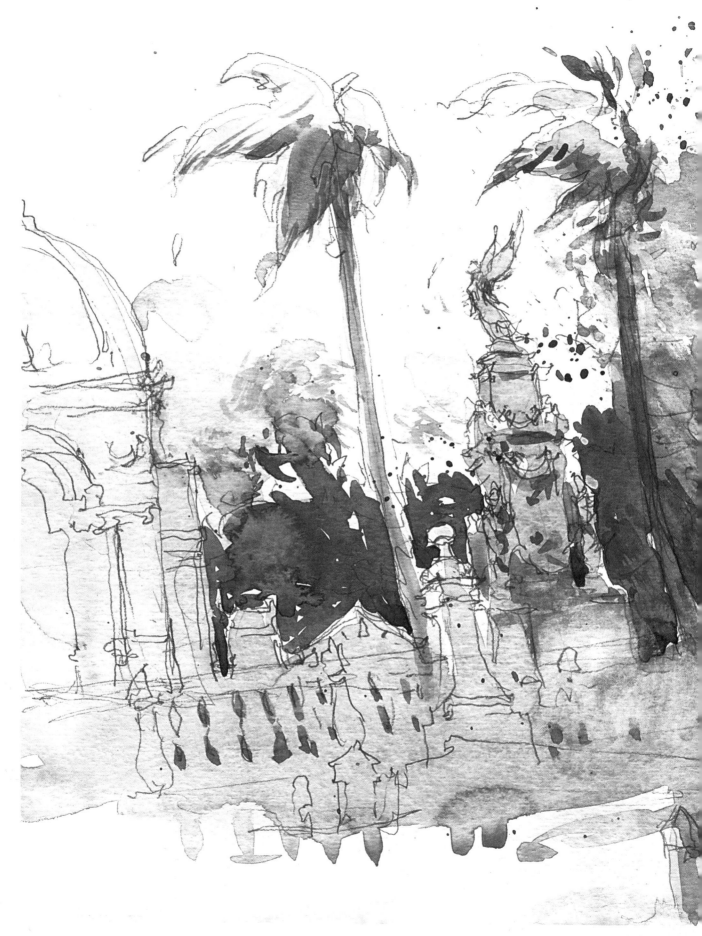

Havana Necropolis
Pen, ink and watercolor on 140-lb. (300gsm) Canson Montval block, 10" × 14" (25cm × 36cm)

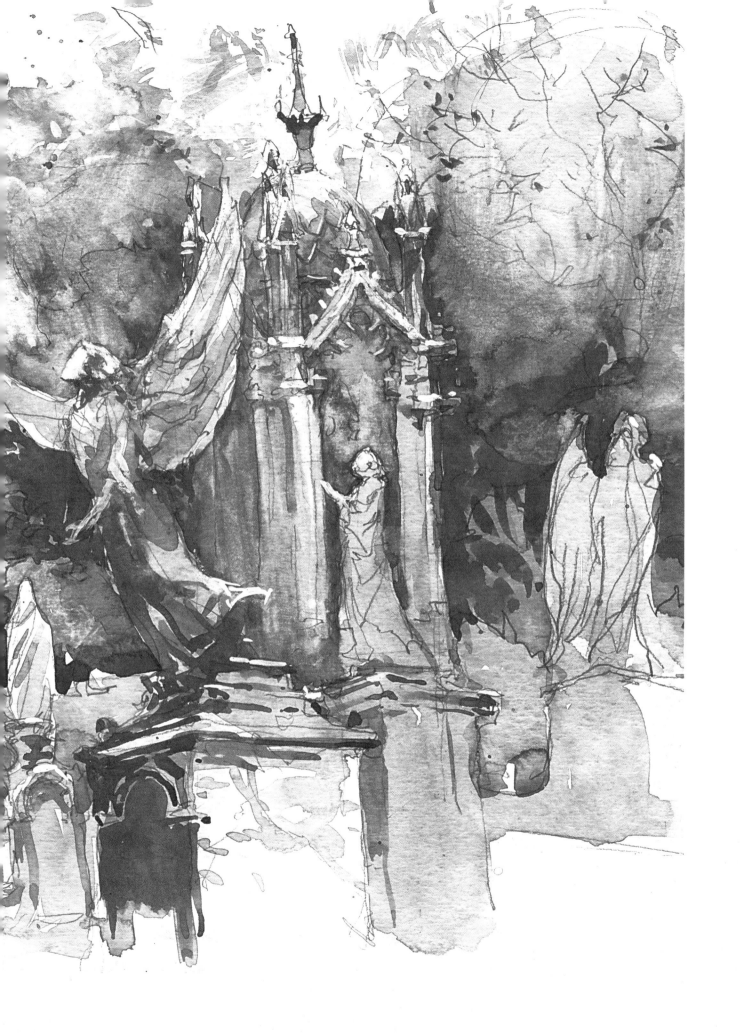

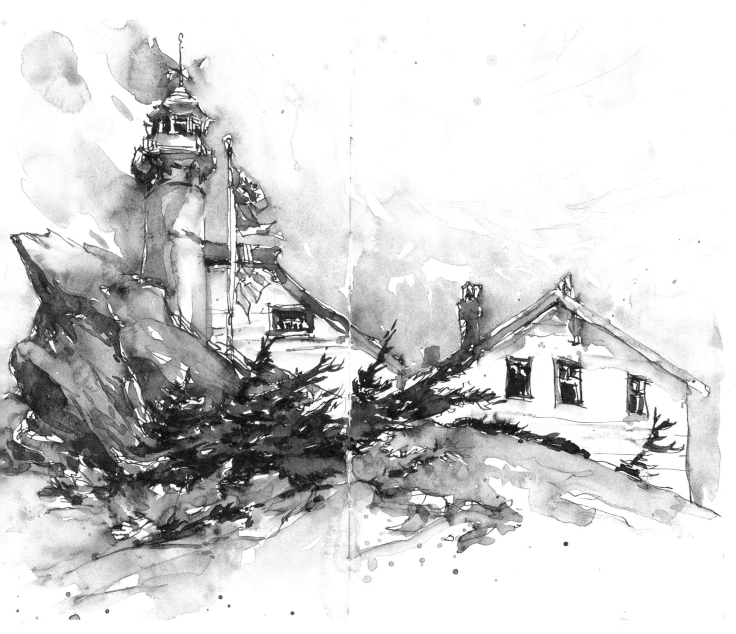

Lobster Cove Head Lighthouse, Newfoundland
Pen, ink and watercolor on Stillman & Birn Alpha sketchbook,
6" × 9" (15cm × 23cm)

Visit artistsnetwork.com/theurbansketcher to access bonus lessons.

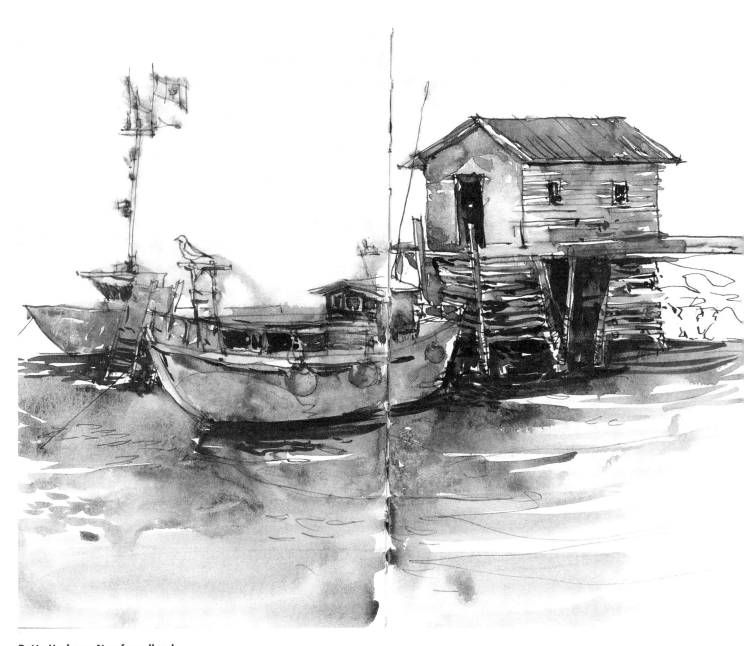

Petty Harbour, Newfoundland
Pen, ink and watercolor on Stillman & Birn Alpha sketchbook,
6" × 9" (15cm × 23cm)

Conclusion

These days, I mostly work in the three-pass watercolor method, although I still enjoy "pure" drawing—especially when there is an opportunity to sketch people in action. For me the watercolor sketch it is the culmination of all my self-training in urban sketching. It's the best combination of drawing and painting.

However, I expect there will always be new ways to push the field of sketching on location. I am already thinking up ways I can do more complex works. I'm trying out even larger scale ink drawings and panoramas in watercolor by painting multiple panels at the same time. I'm continuing to push live action drawing, doing time-lapse sketches of people with interesting jobs. And, I've been experimenting with oils on-location, working directly on small panels, but also painting on top of large drawings on plastic surfaces like mylar and polystyrene sheets. Lately I've also been doing book and magazine illustration using all the principles I've learned from drawing on location.

By the time the book is in print, I will have many more experiments in sketching posted on my blog, citizensketcher.com and on urbansketchers.org. I invite everyone to look me up online and see what I've been up to since writing this.

Good luck with your own work! Don't hesitate to find me on social media and show me what you're up to.

~Marc

Index

Visit artistsnetwork.com/theurbansketcher to access bonus lessons.

a content + ecommerce company

Other fine North Light Books are available from your favorite bookstore, art supply store or online supplier. Visit our website at fwmedia.com.

18 17 16 15 5 4 3 2

DISTRIBUTED IN CANADA BY FRASER DIRECT
100 Armstrong Avenue
Georgetown, ON, Canada L7G 5S4
Tel: (905) 877-4411

DISTRIBUTED IN THE U.K. AND EUROPE
BY F&W MEDIA INTERNATIONAL LTD
Brunel House, Forde Close, Newton Abbot, TQ12 4PU, UK
Tel: (+44) 1626 323200, Fax: (+44) 1626 323319
Email: enquiries@fwmedia.com

DISTRIBUTED IN AUSTRALIA BY CAPRICORN LINK
P.O. Box 704, S. Windsor NSW, 2756 Australia
Tel: (02) 4560-1600; Fax: (02) 4577 5288
Email: books@capricornlink.com.au

ISBN 13: 978-1-4403-3471-9

Edited by Christina Richards
Interior designed by Rob Warnick and Hannah Bailey
Cover designed by Bambi Eitel
Production coordinated by Mark Griffin

About the Author

Canadian born artist Marc Taro Holmes has worked as an art director and conceptual designer at studios such as Electronic Arts, Microsoft and Disney.

His work as a professional sketch artist has inspired teams of digital artists creating interactive adventures in settings as diverse as J.R.R. Tolkien's *Lord of the Rings* and the science fiction epic *Halo*.

Marc has always based the inspiration for his designs on drawing from the real world, sketching in museums on the street, and traveling to draw exotic locations in Europe and Asia.

His love of spontaneous drawing and living a life combining art with experiencing the world has led him to serve as a volunteer board member and artist/correspondent for the non-profit UrbanSketchers.org, an internationally active organization dedicated to expanding visual literacy, promoting the art of reportage, and creating accessible education about drawing on location.

Marc also blogs at citizensketcher.com, where you can find a steady stream of sketches, stories about living an artist's life, and plenty of drawing tips and painting demonstrations.

Dedication

This book is the result of years of experimentation, constant practice and synthesizing of ideas about drawing. There have been many teachers who helped along the way, but none of it would have been possible without my wife Laurel, who is my constant companion. Her support and participation makes our artistic life possible. This book is dedicated to her.

Metric Conversion Chart

TO CONVERT	TO	MULTIPLY BY
inches	centimeters	2.54
centimeters	inches	0.4
feet	centimeters	30.5
centimeters	feet	0.03
yards	meters	0.9
meters	yards	1.1

Plaza de la Catedral, Havana
14" × 20" (36cm × 51cm), Pen, ink and watercolor on Arches 140-lb. (300gsm) hot-pressed block

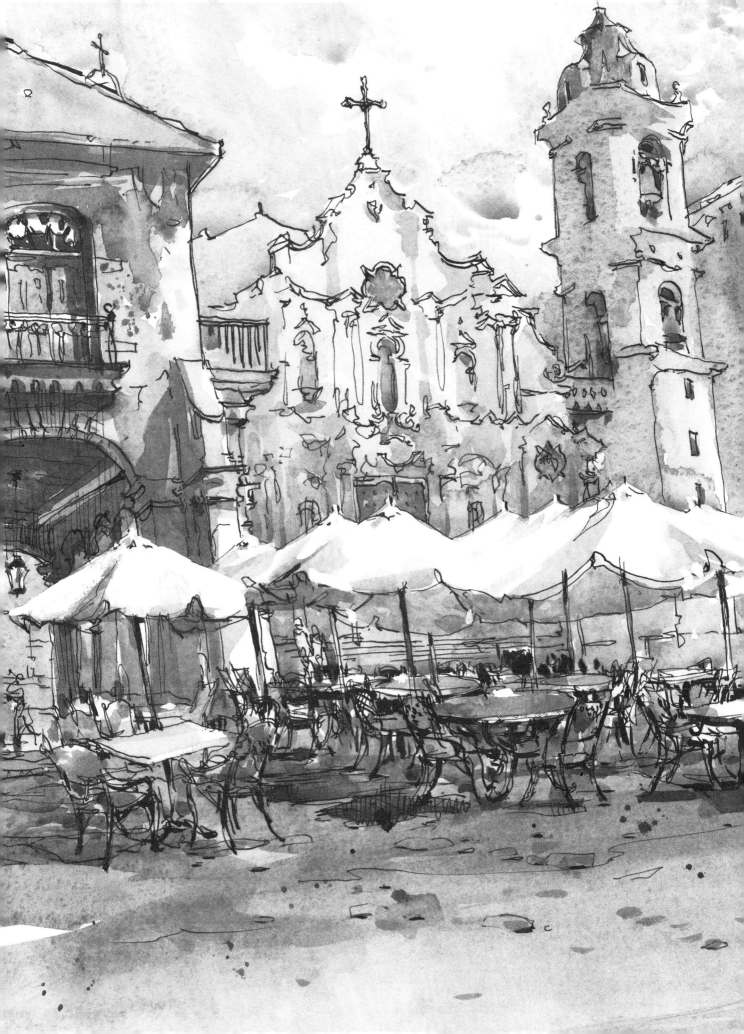

Ideas. Instruction. Inspiration.

Receive FREE downloadable bonus materials when you sign up for our free newsletter at artistsnetwork.com/Newsletter_Thanks.

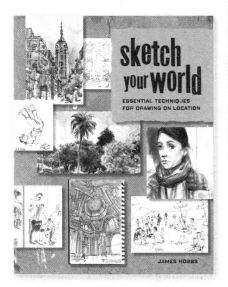

Find the latest issues of *The Artist's Magazine* on newsstands, or visit artistsnetwork.com.

These and other fine North Light products are available at your favorite art & craft retailer, bookstore or online supplier. Visit our websites at artistsnetwork.com and artistsnetwork.tv.

Follow North Light Books for the latest news, free wallpapers, free demos and chances to win FREE BOOKS!

Get your art in print!

Visit artistsnetwork.com/competitions for up-to-date information on Splash and other North Light competitions.